Saving Body & SouL

The Mission of Mary Jo Copeland

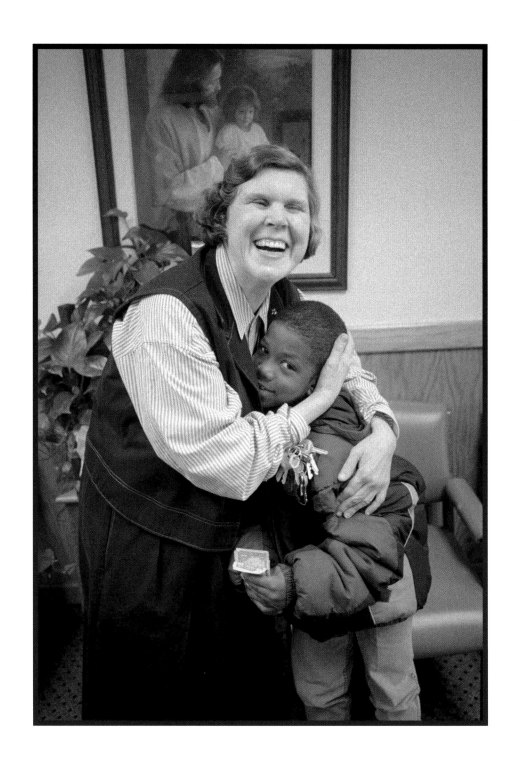

Saving Body & Soul

The Mission of Mary Jo Copeland

Photographs by Keri Pickett

Essays & Interviews by Margaret Nelson

SHAW BOOKS

an imprint of WATERBROOK PRESS

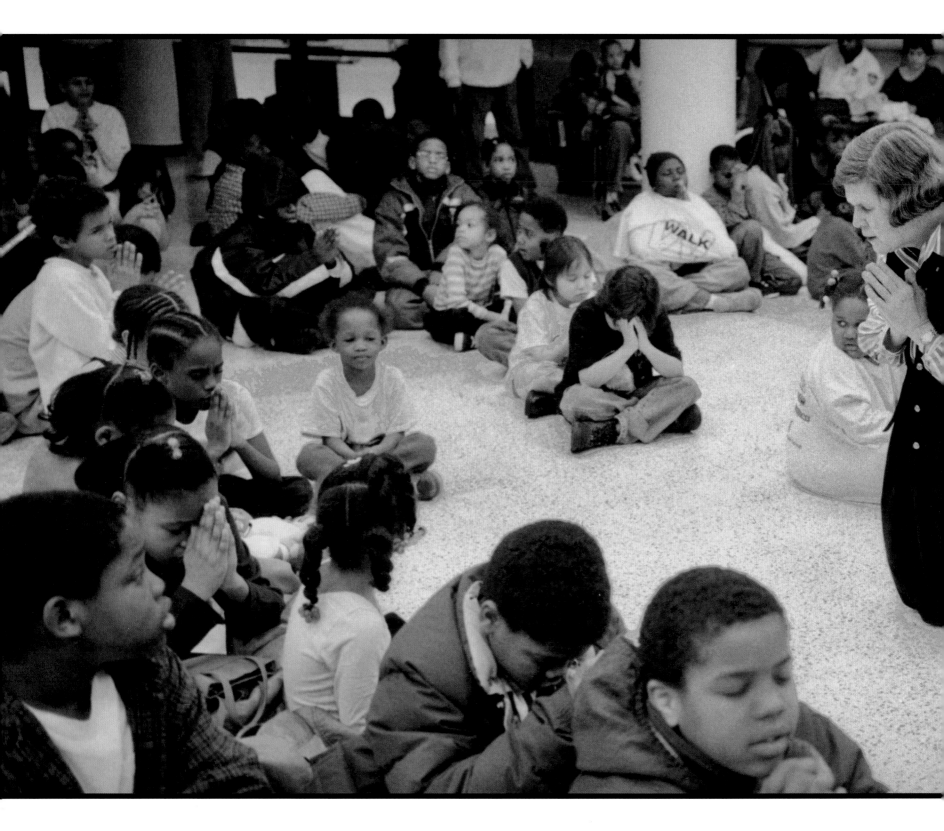

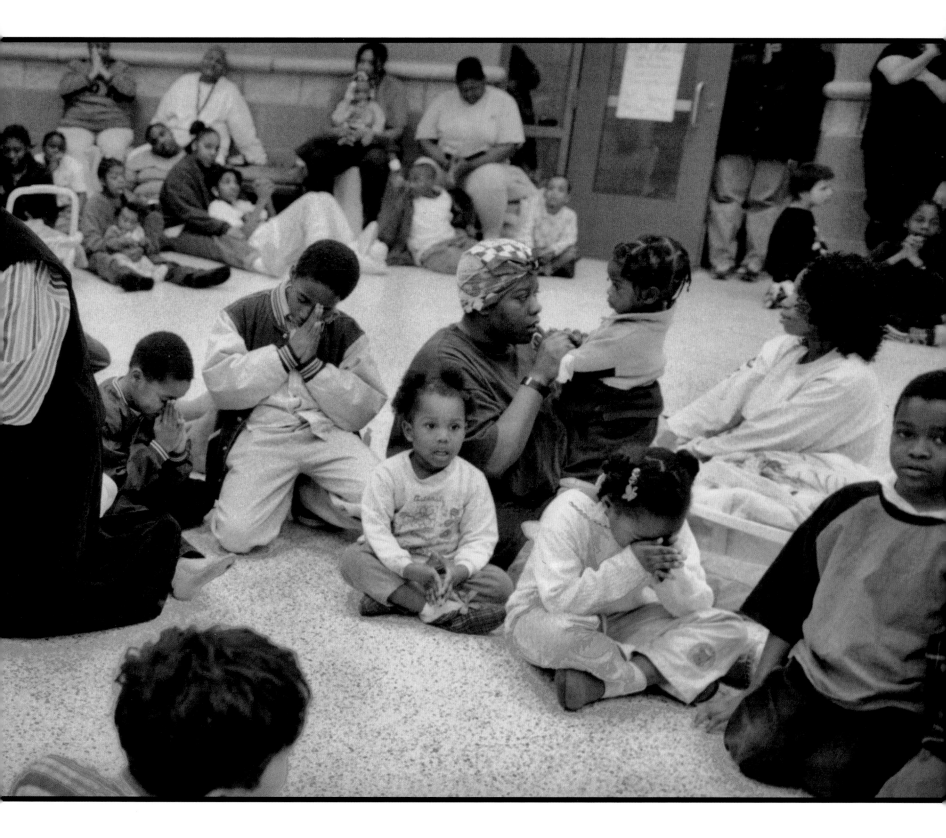

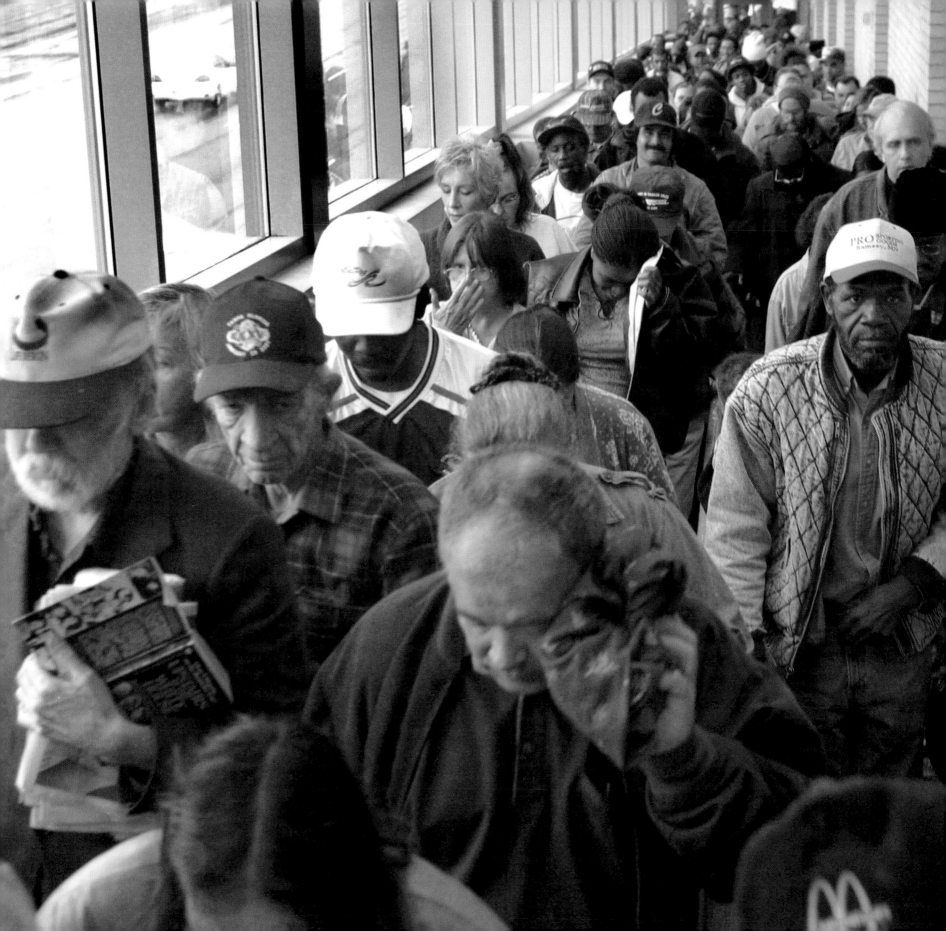

foreword

religious faith is a dangerous thing, a force that can transform lives beyond our imagining. Faith is frightening because it is beyond our control: Christians driven by their faith to great and reckless acts of mercy, such as washing the feet of homeless men and women, do not speak of following their own will, but the will of Christ. Rilke once asked, "Who is this Christ, who interferes in everything?" The story of Mary Jo Copeland provides one answer: Christ is that great interferer who takes a reclusive housewife and mother of 12, and sends her out into the world to boldly minister to many more of God's children. These are people who have fallen through the cracks—the uninsured ill, the jobless, homeless, abused, and forsaken. Surely it is a joke on the rest of us, and on our wasteful society, as we continue to create so many "throwaways," that it is in the stout and unlikely person of Mary Jo Copeland that these people encounter Christ, and experience, perhaps for the first time, the love of God.

The story of Mary Jo Copeland and her ministry is a classic in the tradition of Christian sainthood. People who are so driven, and insist on being accountable only to God, make us nervous. We wonder if they are for real. And we know for sure that they are not easy to get along with. As

so many saints before her—the notoriously irascible Jerome, the difficult Clare and Francis—Mary Jo Copeland has her detractors, who argue, quite reasonably, that she can be arbitrary, stubborn, demanding. But it may be that God needs such adamant, strong-willed people to get the hard jobs done: to translate the scriptures into Latin, to found religious orders in an inhospitable time and place, to house a ministry in contemporary Minneapolis that eschews the cumbersome weight of bureaucracy.

Mary Jo Copeland may express her faith in flamboyant ways, urging sentimental prayers and songs on weary people, but we need to look at the fruits of her labor. It is a good sign that she has inspired so many to turn their lives around, and has attracted so many volunteers to enlarge her ministry. If even street-wise police officers and social workers can see the change she helps to bring into the lives of so many, who are we to quibble? Saints are made by popular acclamation, and not top-down fiat. In the fourth century, Basil was named "the Great" not by a Pope but by the common people of his city, who wished to honor the young man who had spent his fortune on the poor, ill and hungry among them.

If the Copeland ministry outlives Mary Jo Copeland, as is clearly her intention, in 50 years or so the human weakness of the founder will be nearly forgotten, or remembered in stories expressing wonder at how God works through our frailties and sinfulness to do holy work in His name. We can only keep on serving the needy, and recall the promise that Jesus Christ has made to us: that as we welcome the least of these to the table here on earth, we are welcoming Him. And that He, in turn, will recognize and welcome us when we enter God's kingdom in heaven.

But this foreword cannot end here. We need to ask why there is such a mean spirit in our land. Why, as a society, are we so negligent with human beings who are made in the image of God? Why are we so willing to toss God's children out with the trash? A woman loses a job and can't get training for another that will allow her to support her children. A man injured on the job receives no disability, and ends up on the street. Orphans are neglected or abused, reeling in and out of foster homes, never encouraged, never told they are worth anything. How, in a land of abundance, that takes pride in its religious values, has this sinful condition taken hold of us in such seemingly intractable ways, so that it seems the norm? This is perhaps the most disturbing question raised by the ministry of Mary Jo Copeland. She is doing what she can to serve people now. But it is we, as a people, who must come to terms with the ugly mess we have created, and work together to find an answer, and a remedy.

KATHLEEN NORRIS

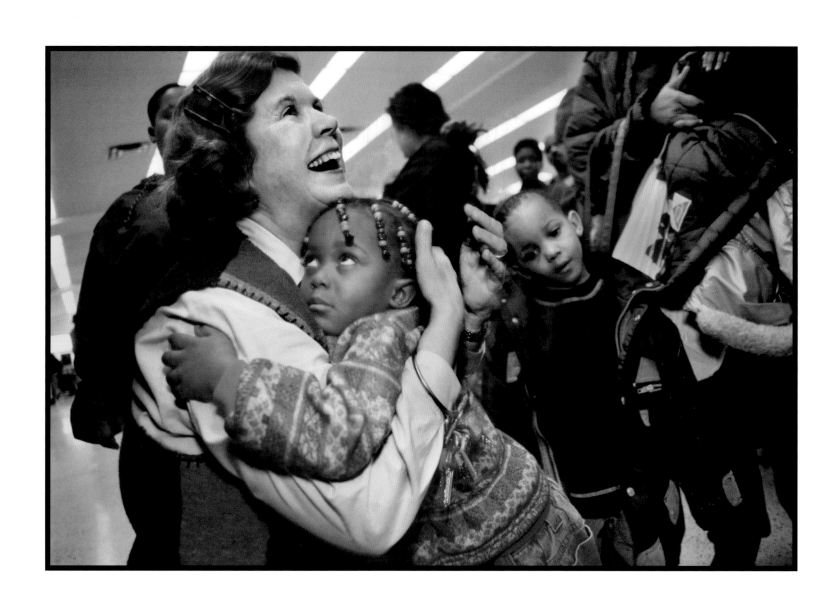

a very good story

*a*s a reporter, you can always tell when you have an especially good story. You think about it all the time, tell everyone you know about it, find the faces and words and ideas turning up in your personal life.

That's how it was with Mary Jo Copeland. I first encountered her shortly after she began her work almost 20 years ago. She gave the Sunday homily at my parish church, talking about how she'd raised 12 kids and now needed help to spread love and kindness to the poor and homeless. I called, introduced myself, and asked if I could see her in action. She said, "Of course! I'm here."

After watching her work, I was hooked: This was a story I wanted to tell. I saw her touch people in a way that few ever do, soothing wounds of both body and soul. She walked happily among people many of us go out of our way to avoid. She laughed and cried and prayed with them, washed their feet, gave out bus tokens and motel vouchers and dollar bills and hugs. With only a high school education and with no previous experience, this slightly zany, faith-filled, suburban homemaker had become both the best and last resource for the poor and homeless of Minneapolis. Others could learn from her, replicate what she was doing: Poor people nationwide could benefit. I spoke of her to my editors and to my friends, including the acclaimed photographer Keri Pickett. In 1999, Keri and I collaborated on a story for *People* magazine about Mary Jo and her work and we knew we wanted to do more. We've been working on this book ever since.

Along the way, I've found myself applying Mary Jo's words to my life, her trademark phrases giving voice to my own deepest yearnings. "Be a positive presence in the world. Make the world a better place because you're in it." What better goal? But she gets more specific. "Treat the people who come to you as if they are Jesus–and as Jesus would treat them." Hmm. That can be tough. But don't worry, you can do it. "Look at me," Mary Jo says. "I'm this kinda crazy woman who had a terrible childhood. If God works through me, He can work through anybody!"

So go forth. As Mary Jo says, "Just do your best."

margaret nelson

10

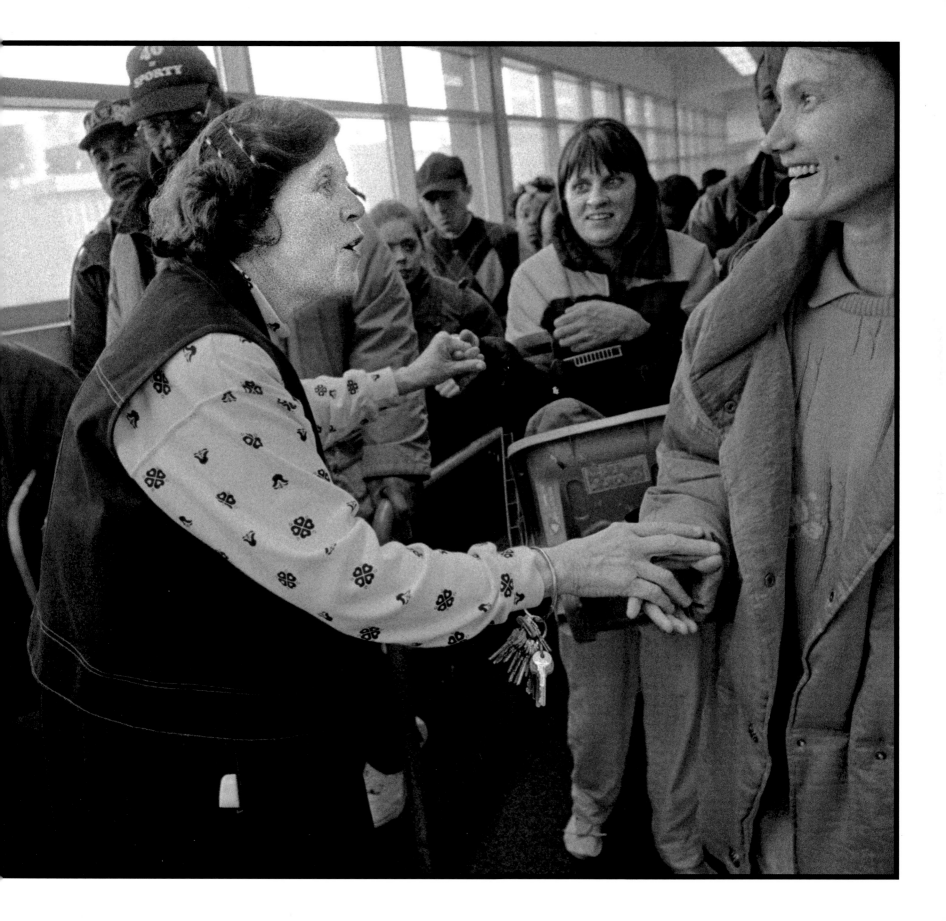

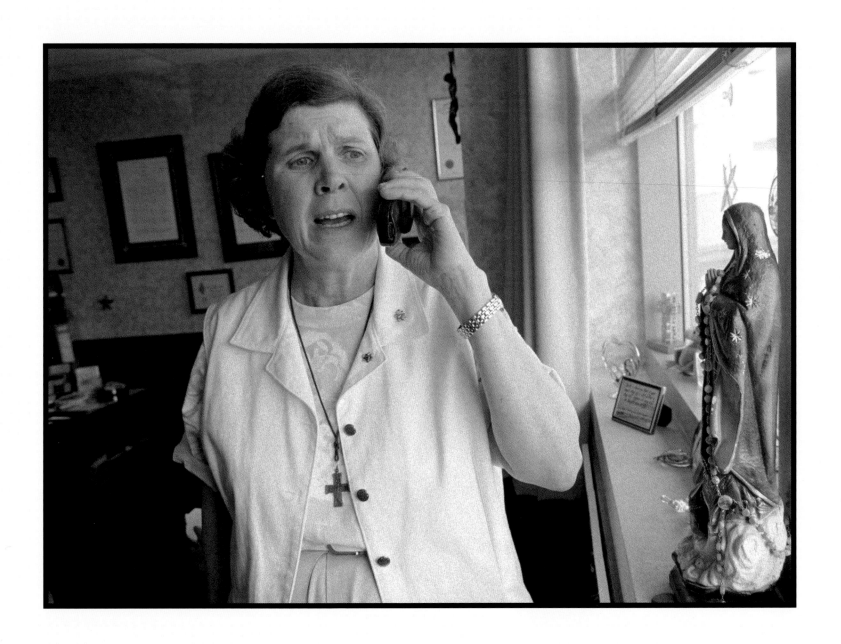

The phone rings constantly at Mary Jo's Minneapolis office. "People who need help,
people who want to help—I don't like to turn anyone away."

"God loves you, and I love you. Never forget that." –Mary Jo

mary jo's story

Mary Jo sees herself in the children—little girls who come to her in mismatched clothes, boys with dirty hair, babies crying out of fear or hunger. Most are scared, suspicious.

She still cries, remembering her own childhood. Shaking in bed, night after night, she'd cover her ears and pray for help, hoping her father wasn't going to kill her mother as he beat her across the hall. Other times, she'd cower, sometimes hiding in the attic, when her father would turn on her. He'd call her stupid and crazy, and tell her she was no good. Screaming, ranting, sometimes hitting, he'd say she'd never amount to anything, never be loved by anyone. She worried that he was right. Her mother tried to stay calm, to keep the household together, even playing bingo to earn money for food. Mary Jo tried not to be a bother. She did her best to stay out of the way.

At least once a week, Minnesota weather permitting, she'd ride her rusty Schwinn to Bachman's garden store nine blocks away and ask for leftover flowers to set before the statue of the Virgin Mary at Annunciation Catholic Church. The flower ladies were kind; they'd smile and let her pick out some wilting daisies or nice pink mums. Even then, Mary Jo was always praying. She believed that God was watching over her, protecting her.

Now, she wants these children to know that someone is watching over them too. She hopes they'll find strength in faith and that they will believe in God. And she wants them to know that Mary Jo is going to do what she can for them, that Mary Jo is one of God's helpers on earth, a kind of human guardian angel, here to try to make life better. Her grandparents did that for her when she was very young, and she still remembers their love and kindness: She knows these children will remember her too. She helps adults, of course—hundreds every day. But it's the children who steal her heart.

She looks like an aging Girl Scout: rosy cheeks and China doll skin, white running shoes, dime store barrettes holding back her old-fashioned Dutch Boy bob. The extra-deep pockets of her pressed denim skirt and matching vest bulge with dollar bills, gum, and other treasures for the children. A silver cross bounces on her broad chest.

Speed-walking through her Minneapolis shelter at a pace that leaves far younger people straining to catch up, Mary Jo Copeland calls out orders to the cadre of volunteers who gather round her like pups. Now 62 years old, the mother of 12, she's an odd but beguiling blend of prayerful saint and slightly daffy, hands-on executive. But there's never any doubt of her purpose: "I want to do what Jesus would do, accept people as they come to me," she says. "To see Jesus in everyone and treat them as Jesus would—that's what I try to do. I do my best."

Mary Jo's grandfather, who loved photography, posed Mary Jo at age six.

Since beginning her outreach to the poor and homeless in 1985, Mary Jo's vision has grown from two coffee pots and a box of doughnuts in a rundown, rented building to what one social worker calls "Mary Jo's Mall of America for the Poor—everything you need in one place." With the help of church groups, student service projects, and hundreds of individual volunteers—from former street people she's helped to retired executives—she serves meals to more than 1,000 people a day; provides transitional housing to 92 families at a time; distributes food, clothing, medical care, cash, prayer, and hope to the poor and homeless. She's a legend from the streets to the corporate boardrooms.

Wayne Irving is a case in point. Just in from Chicago, he'd spent the weekend at the bus station, trying to get his bearings. "Someone told me to come here to Mary Jo. No last name. Everyone knows her," Irving says, waiting his turn in the morning line. "I came for her advice, mainly. Hopefully, she can help me find work. Hopefully, she'll help me find a place to stay, a shower." Within a few minutes, Irving is soaking his right foot in a plastic tub of hot, soapy water, while Mary Jo, on her knees, her hands in thin clear plastic gloves, gently rubs his callused left foot with antiseptic lotion. She says it's what Jesus would do if He were there: Jesus washed the feet of the poor, now she's doing the same. Irving is amazed. "I've never met a lady like her in my life. She's washing my feet. Nobody ever did that. She's beautiful." She's also practical, arranging for him to stay at a nearby men's shelter, giving him bus tokens and a new pair of shoes. Then she sends him off with a quick prayer, one of at least hundreds she'll say that day.

Mary Jo's been praying ever since she learned the Lord's Prayer from the nuns in grade school. "Prayer got me through a lot in my life," she often says. "It was prayer that helped me feel connected to something greater. I felt like I was having a conversation with God, that someone was listening to me."

The older of two children of the late Woodrow and Gertrude Holtby, Mary Jo grew up in a modest two-bedroom bungalow in a working-class neighborhood a few miles south of downtown Minneapolis. It was a lonely childhood: Her younger brother John was

The Holtby family smiled for the camera when Mary Jo was seven.

mentally ill; and she believes her father was also mentally ill. A wholesale rep for a clothing company, Woodrow Holtby might have been able to hold himself together at work during the day, but at night he'd explode. "He'd get up in the middle of the night, three in the morning, and rant and rave. Once he beat my mother so bad her eye almost fell out of her head," Mary Jo says. Tears stream down her face as she thinks over those early years. "I grew up in a very sad family. I lived in a corner of my room. I'd go to the bingo halls at night when my mother played for food. Sometimes we ate, sometimes we didn't. My dad worked, but he didn't give us anything. My mother didn't clean the house. Everything was filthy. I didn't take baths; I don't know why. I just didn't."

The sadness extended into life at school. "I didn't get good grades. I guess I couldn't concentrate. I couldn't study and get my work done. I was always kind of on the outside. The kids would make fun of me. I wasn't very clean. They'd cough like I smelled. I probably did. I was different from the average child."

Even now, the painful memories sometimes overcome her and she'll sob. "When I look back, I was always on the outside, people making fun. My dad told me I wasn't worth anything, not worth a hill of beans. He'd say, 'You'll never amount to anything, Mary Jo. You're a nobody.' And nobody else treated me like I was worth anything either." As a child, she'd go from one neighbor to another, asking if she could take some flowers from their yards to her parish church. "I think people thought I was a little goofy, being so religious," she recalls now. "But it gave me such comfort. That was all I had."

In 1992, a few years before she died, Mary Jo's mother told a *Minneapolis Star Tribune* reporter that her daughter tended to exaggerate. "I don't think this needs to be public," Gertrude Holtby said, reportedly speaking in the same strong cadences as her daughter. "I don't know why she does this. But she always was a little different, high-strung." Mrs. Holtby, who'd gone on to own a suburban dress shop, "Gertrude's Apparel," after Mary Jo was grown, admitted that her marriage had been troubled and did not deny the family trauma. "I was the one who held things together. He had a mental streak, poor fella, and there was no talk of divorce in those days, you know. A person hates to talk about this, and I don't know why she does. I suppose it's to get more money, but she's doing fine. People support her. And she's got a good mother here who stood by her 100 percent."

Mary Jo shakes her head at that. She says she didn't feel her mother's support, nor anyone else's, when she cowered in the bedroom, praying that her father would stop beating her mother, "that we could have a nice home...I'd ask God to let me get through this, let me do good in the world." She says it was a classic case of keeping the secrets inside. "Nobody knew the whole story. Everybody knew my father was crazy, but they hid it. My aunt never believed me, how bad it was." But she says a monk befriended her and found her a foster home after

Mary Jo, at age six, recalls many happy days as a young child in her grandparents' care.

she'd turned 18 and could move without her parents' permission.

Meanwhile, her future was beginning to take shape. At a sock-hop mixer between their two Catholic high schools, Mary Jo got up the nerve to approach Dick Copeland, the man she would marry. "He looked so nice, so I went over and asked if he was someone else, just to get a chance to talk," she recalls, giggling like the schoolgirl she was then. "He bought me a Coke, asked me to dance. It was real special." She cries remembering how his family rejected her. "They were prosperous, prominent in town, and they didn't think I was good enough for Dick. When we were dating, we'd drive over for dinner, but they wouldn't let me come inside. I'd eat in the car and wait for Dick. His father offered to pay for a psychiatrist if I'd leave Dick, if we wouldn't get married. When Dick made the decision to marry me, they walked away. I tried for the first three years to have contact. I'd really wanted to have a family, to be accepted by his family. But then Dick said we had to go forward. We'd have our own family and be fine." She considers Dick a miracle. "God knew how much I needed someone, how much I wanted a family," she says. "He blessed me with a wonderful husband and 12 beautiful children, and now more and more grandchildren."

Dick Copeland doesn't like to talk about the early years or the estrangement from his family. "My mother was a very controlling, sophisticated woman. She had her own ideas of what she wanted for me, and Mary Jo wasn't it." But he says he never regretted or questioned his decision to date, then marry, Mary Jo. "She was very wise and thoughtful, and a lot of fun," he says. "I've been loved every day of our life together; it's been a wonderful marriage." He says he's had no contact with his family "for well over 30 years" and knows nothing about his mother or his siblings.

After graduating from The Academy of the Holy Angels high school in May 1960, Mary Jo worked as a nurse's aide until marrying Dick the following April. He took a job and they settled into the kind of family life Mary Jo had always wanted. Their first child, Theresa, was born 10 months later, followed by 11 children (and two miscarriages) over the next 14 years. Soon, however, the ever-growing responsibilities began to take their toll. Mary Jo looks back now on the emotionally demanding, back-breaking work of raising her large family and wonders how she did it. "Thirteen loads of laundry, all those meals, ironing their little school uniforms, making sure they got their homework done, got to the doctor when they needed to, plus making time to be sure they felt special—reading to them, praying with them, never letting them go to bed at night without a hug and 'I love you.' It was incredibly

gratifying but also exhausting," she recalls. "And I was dealing with my own childhood issues, plus the physical and emotional stress of having all those pregnancies. It was tough, believe me." She says it was her faith that got her through. "Sometimes I'd pray all day, asking God to help me be a good wife and mother, to get through the day. Dick was a wonderful father and husband—we were always happy together—but he worked a full-time job. I was the one at home."

She talks candidly about years spent in housecoats, barely going outside. "I didn't have any friends. The neighbors thought I was crazy for having all those kids. I didn't have time to do anything outside the home, plus I wasn't confident. Dick and the children were my world." Her youngest daughter, Molly, was born in 1975. It was a difficult Caesarean that resulted in a hysterectomy. Though Mary Jo felt it was God's will ("I always believed that God wanted me to have those kids and I always said God was in charge of how many children I had," she recalls. "When He thought I'd had enough, He took care of it"), she suffered a devastating bout with depression. She went on Valium ("the drug of the day," she recalls), then fought to get off it and on with her life.

Wincing at the memory, her son Mark, now a teacher, says he defended his mother when childhood friends made fun of her. "We all knew our mom had problems. Some days she'd really be suffering. She hardly went out of the house for years. I had friends who'd say she was weird—she had all those kids, she never went out. I felt sad for her. I knew she'd had a bad life growing up. It wasn't her fault."

Mary Jo's first-born, Theresa, is a nurse who also remembers those days with compassion. "She battled a lot of problems from her growing up. Mom pushed through it all. She had all these kids, no one to help. So she struggled a lot on her own. She took Valium at one point, saw a psychiatrist for a while, had a priest she talked to." But she rarely left home. "For a good 13, 14 years, she only left the house to go to the doctor or to church. She lived in housecoats."

With 14 people crammed into a tiny 865-square-foot bungalow, Mary Jo had no secrets. "She'd talk about her troubles," Theresa recalls. "She'd openly say, 'I'm having a lot of sad feelings.' She had to talk with us. We were all she had."

But the depression was only one part of life at home. The children remember games, prayers, lots of laughter and special occasions. "My mom wanted to give us what she didn't have growing up," Theresa says. "So we had a lot of love, a lot of fun, wonderful things. She'd make up little games for us, make things special. We always had Chinese food and little hats on New Year's, always lots of presents at Christmas. We always had treats—cookies and candy and gum, because Mom didn't have treats growing up, so we were going to have them." But it was more than material things. "There were always hugs before bed. We felt very loved. And we always had whatever we needed. I'm sure money was tight with all those kids, but we always felt special. She'd always tell us, 'God loves you and I love you.' It's what she tells the poor and homeless people who come to her now. She makes it very simple. She kept reminding us that God loves us. That sticks."

She prayed with her children just as she does now with the children in her transitional housing apartments. Mark and Theresa can still almost recite their mother's version of the Stations of the Cross, the Catholic prayer meditation that follows the steps of Jesus on His last day. "She'd personalize it for us," Mark recalls. "She'd get to the part where Jesus falls and she'd say, 'Lord, sometimes we fall

Mary Jo made her first communion, and learned her favorite prayers, at her south Minneapolis church.

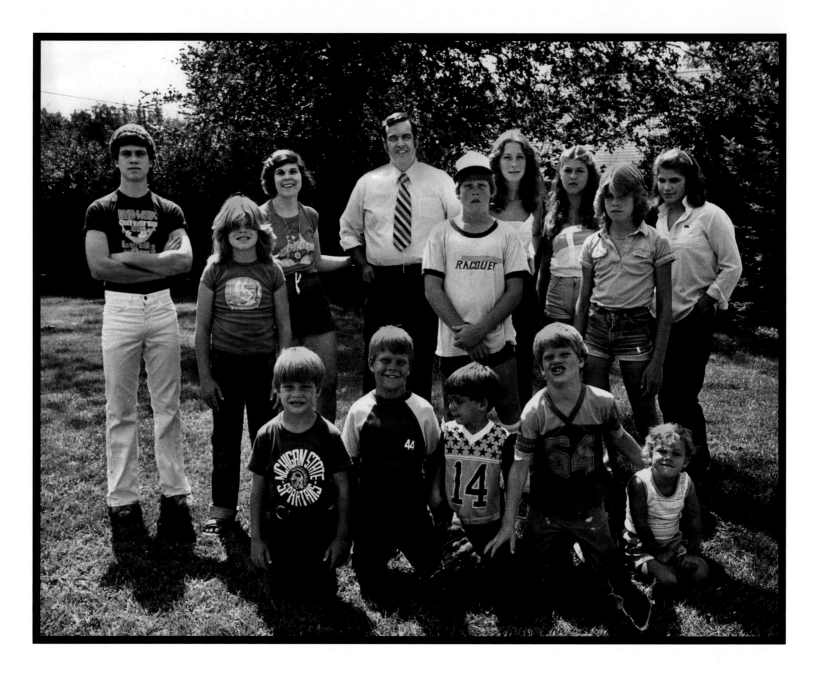

too. Sometimes we make mistakes. Help us get up and go on.' I can still remember the words, everything she said, at every station. It really made an impression." Mark says he and his siblings–Theresa, Andrea, Mike, Catherine, Jennifer, Barb, Steve, Jim, Jeff, Matthew and Molly–have much in common. "We were all taught to make a difference in the world. Just like she does with the people she helps now, Mom would say, 'Make the world a better place by your presence,' and we all try to do that. We're all kind people."

There are other similarities between the Copeland children and the children Mary Jo now serves. "We saw depression, saw Mom struggle," Theresa says. "Maybe as a child you're a little more grown-up, a little more aware, when you see suffering. I liken it to the kids you see at Mom's place: Some of them have seen so much sorrow and suffering. But they're also often more sensitive than the average child. That was true of us too. Suffering is hard, but what it brings, sensitivity, is always good."

"If you see something that needs to be changed, change it. If you see people who need help, help them. If you see something that needs to be done, do it. Be Jesus' hands, His heart, His feet, His mouth." –Mary Jo

"So is a little organization, a little cleanliness," Mary Jo says often. "She grew up in a filthy environment, so she is very methodical about keeping things clean," her eldest notes. All 12 Copeland children had chores, an assigned shelf for their shoes and schoolwork, and a specific stair (counting down from the attic by age) for their next day's underwear and socks.

When the youngest went off to school, many at-home parents of 12 might have looked forward to time for an extra cup of coffee or a visit with a friend. Not this mom. As Molly was about to go to kindergarten, Mary Jo panicked. She didn't know what she'd do with that four-hour window and no children in the house. As usual, she confided in Dick, talking over the kitchen table while the children did their homework. "Dick was always encouraging me, telling me I had so much to give," Mary Jo remembers. "He said I had to get out into the world and share my love." With Dick's encouragement, and the cheering of her children, she ventured out.

Her children still recall that day with amazement. "She said, 'Kids, I'm going out to share the love we have in our family with children who don't have that love,'" Theresa recalls, laughing. "It was wonderful, especially for someone who had hardly left the house for years. We couldn't believe it, but we were totally behind her. We wanted her to be happy." Mary Jo felt it was God's calling. "I'd always told God I'd do something good someday. I'd make Him proud."

In 1981, Mary Jo, then 38, took off her housecoat, hung a silver crucifix around her neck, and went out to share her love through charity work. She began by volunteering every morning at Catholic Charities' downtown Minneapolis program for the poor. Shy, still feeling the wounds of jeering classmates 20 years after high school graduation, she was worried about whether she'd be accepted by other volunteers. But she knew she could be helpful. And she felt called. All those years at home, she'd begged God for help; now she felt she owed something in return.

"I didn't know how I'd fit in at Catholic Charities, but I knew I had common sense," she recalls. "I could work like a horse. And I had so much love in me. I wanted to help people, especially the poor. I believed in what Jesus said about being with the poor, helping the less fortunate, doing that in memory of Him."

Jesus was a rule-breaker, and Mary Jo turned out to be one too. Within weeks of going to Catholic Charities, she had two mantras: Follow Jesus and avoid bureaucracy. More precisely: "Follow what I think Jesus commands me to do, even if it's against policy" and "don't get bogged down in bureaucracy and paperwork. If people are hungry, open the food shelf and give them food." But her approach quickly created problems for the more regimented volunteers and staff. "A mother would come for food, but it was after the food shelf was closed and they wouldn't let me open it," Mary Jo recalls. "I'd say 'meet me at the back door' and bring her food. And I'd do the same if people needed socks or something like that. I tried to do what Jesus would do–see Jesus in everyone

This rare photo of Mary Jo and Dick Copeland and all 12 of their children was taken by Minneapolis Star Tribune *photographer Art Hager in 1980, when the paper did a story about the family. Its title: "It takes love–and lots of yelling–to raise 12 kids."*

who comes to you and treat them as you think Jesus would. I knew Jesus wouldn't turn away a hungry mother and her children."

Looking back, she's proud that she was fired; she figures Jesus suffered for His beliefs, and she suffered for hers. No one representing Catholic Charities at that time is around to comment and current leaders say they have no record of what happened back then. There's the sense that no one wants to relive past difficulties. In fact, The Most Reverend Harry Flynn, the current archbishop of the Catholic Archdiocese of Minneapolis and St. Paul, says he is "delighted and moved" to know Mary Jo; he compares her favorably to Mother Teresa. But that doesn't mean she'd fit into an organizational structure. In an environment where rules and forms defined who got what, Mary Jo's hands-on, gut-and-heart level approach to decision-making didn't fly. "I'd see people being turned away, because they didn't qualify for this or that. Poor people, afraid, with no place to turn," she remembers. "I couldn't stay still. I couldn't be quiet. I'd open the food shelf for them, and then I'd get in trouble. I'd ask to make exceptions, and then the staff said I was a trouble-maker. I'd bring stuff from home for the poor, stuff Dick would let me buy, and I'd tell the staff, 'If Jesus were here, He'd help these people.' It was a bit of a problem having me around!"

She did notable work, recognized by the broader community: A local television station gave her a prestigious service award for organizing area churches to bring food to the Catholic Charities outreach center. But after three years, Catholic Charities asked her to leave. She was devastated. "I was heartbroken, rejected again, like I'd been all my childhood," she says. Once more, her husband came to her rescue. "Dick told me that maybe this was a good thing, that I'd find another way, my own way, to serve. He was right: God had other plans. If it had worked out at Catholic Charities, I might never have started Sharing & Caring Hands. I listened to God and this is what happened."

Devoted to her prayer life, Mary Jo gets up at 3:30 every morning so she can be at church by 5 a.m. to hear what God has in mind for her. She trusts that God's will is behind everything she does. "I totally rely on God. I get up in the morning and run to Jesus' arms," she says, describing her solitary vigil at the church across the street from her suburban home. The priest gave her a key because no one else is up so early. After her private prayers, she joins others who gather for the 7 a.m. mass, usually serving communion. Then she heads to the downtown shelter where the poor wait. "I start my day with prayer and all day long it's the same," she says. "All the decisions—what to do, where will the money come from, who can we help, who we can't—I don't worry because I know God is with me. It's a total trust in God. I look at every day as a new day and God will get me through that day. He always does."

After a full day, Dick and Mary Jo relax at home with a bowl of popcorn and a bit of television. On Saturday nights, they go out to their favorite place for dinner and dancing. They haven't had a vacation in years. Dick says he asks his wife, "When are we gonna rest?" And Mary Jo replies, "We'll rest in eternity, Dick."

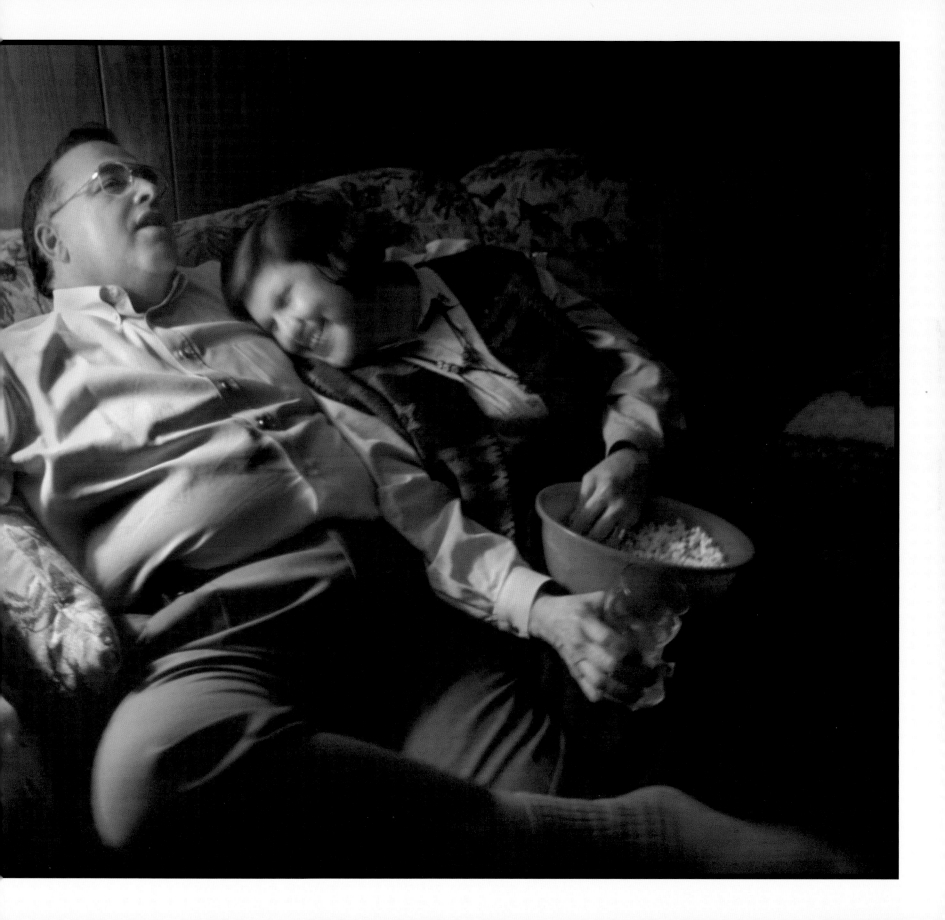

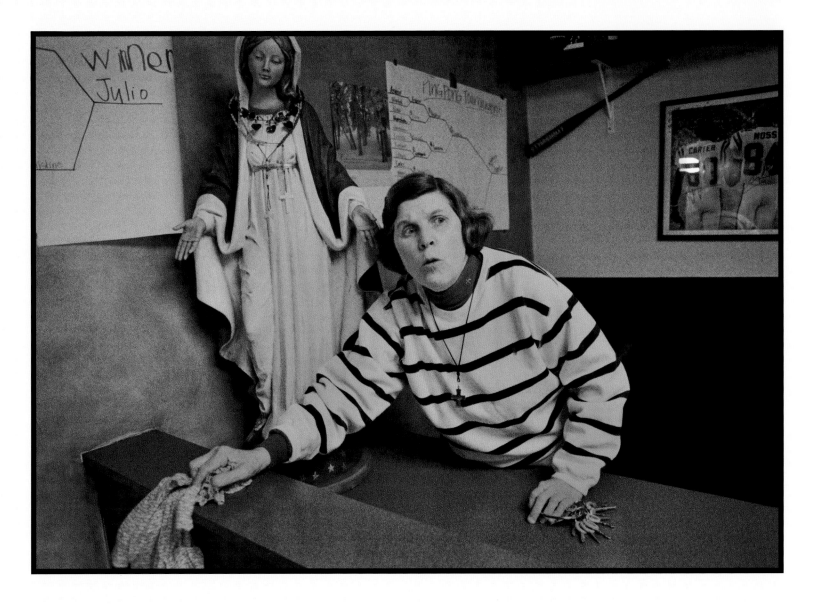

She says it was God, "and a bit of common sense. I'm not stupid you know," that kept her moving forward after Catholic Charities. She'd already been distributing food from her car, parking near an old bar not far from the railroad tracks. "Pretty soon I saw they needed coffee, and gloves, and clothes. It just kept growing."

Convinced of the need and sure of her ability to meet it, Mary Jo quickly moved to open a storefront drop-in center. She'd call it "Sharing & Caring Hands," and her vision was simple: a building that would be heated in the winter, with hot coffee and decent doughnuts and whatever else she could come up with to help the poor. In 1985, she took the $2,200 prize she'd won for her Catholic Charities' work and got a lease on a run-down building in a shadowy district of downtown Minneapolis. Dick, by then senior buyer for a major grocery chain, co-signed the paper with some trepidation. "I signed the lease. I was on the hook for $36,000 in rent," he recalls, shuddering. "I said to Mary Jo, 'What's the

Mary Jo and her daughter Barb spend Sundays cleaning at Sharing & Caring Hands. "I like things to be nice for people," Mary Jo explains. "It makes them feel special if the place is clean and fresh."

*"Don't pray too long, you'll get it wrong.
We must go from prayer to action."* —Mary Jo

sentence if I don't pay?' but she said, 'Don't worry, honey. It'll be okay. I'll get some coffeepots and open the doors and see what I can do.'" The place was like a magnet. The poor lined up around the block, and the services quickly grew. "Before long," Dick recalls, "she realized that these people needed a place to bathe, they needed clothing, treatment, money. It's the way she still does things—she sees the need and pretty much does what she can to help and has faith that God will provide. She prays a lot, is in close touch." One frigid winter morning she went out and spent $800 on gloves. Once again, Dick worried. "But she said, 'Don't worry, honey' and the next day a guy walked in and donated $800. He was retired. She not only got the money, she got him. He was one of her first volunteers."

With each success, the once reclusive homemaker grew more confident, more ambitious in what she could do for the poor. When the City of Minneapolis condemned her first building to build the Target Center sports arena, she offered $250,000 to buy a building a few blocks away. "I proba-bly should have figured it out by now, figured she'd get the money," Dick says, grinning at the memory. "But I still worried." Mary Jo promised she'd have the money by the closing. And she did.

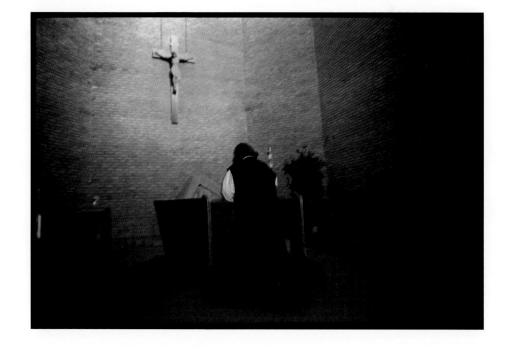

Her children were amazed at their mother's trans-formation. "You have to understand, I've been here from the beginning," Mark Copeland says. "I watched my mother struggle with her own issues over the years—rais-ing 12 kids, dealing with the horror of her own childhood. My mom didn't have what other kids had growing up. She didn't have love and caring. She didn't have anyone saying, 'Hey, you can do it. We're praying for you.' Some people never recover from that kind of life."

He was 15 when he realized his mother's gifts. He laughs out loud remembering the day. "My mom told me to turn off the phone and send the younger kids across the street to the park to play. She needed me to time her while she practiced a speech. She was going to speak at a church about her work and ask them to donate money," Mark recalls. He was shocked. "You have to understand, my mother had never given a speech in her life. She'd been home with kids all that time. But she stood there in the living room and talked about her life and what God was calling her to do. It was all the stuff she taught us growing up—that God loves us, that God wants us to make the world a better place by our presence. I'll never forget it. Twenty-five minutes later, she'd laid it all out. It was beautiful. I said, 'Mom, you are going to be another Mother Teresa.'"

Just as when she was a child, Mary Jo begins each day with quiet prayer.

23

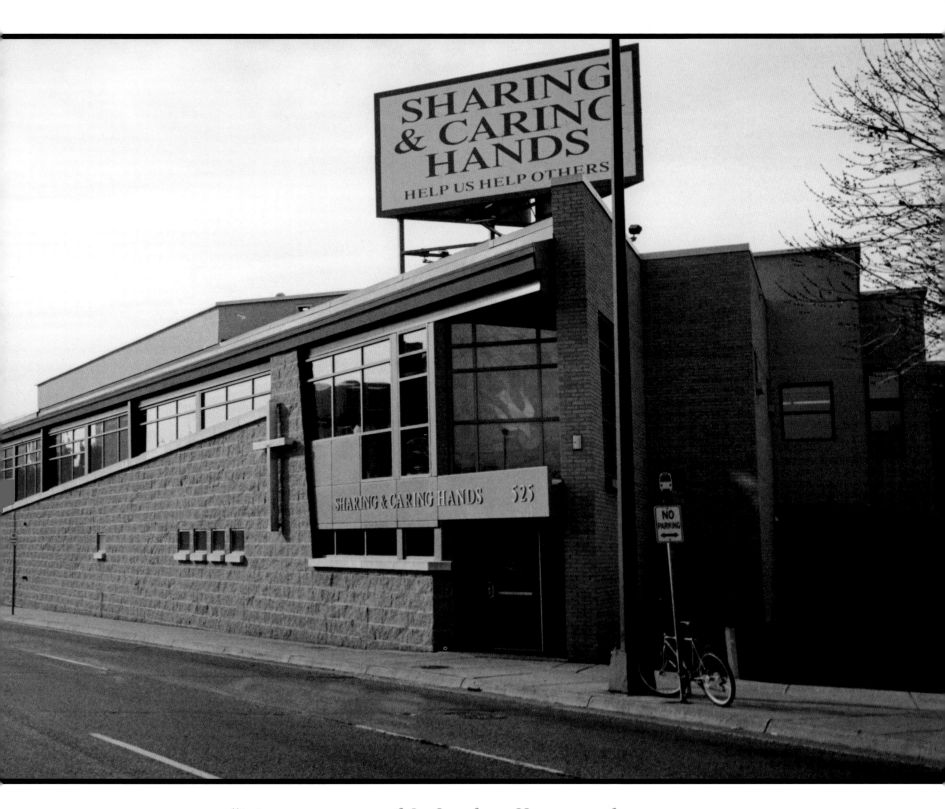

"We are responsible for the effort, not the outcome.

The outcome is in God's hands." –Mary Jo

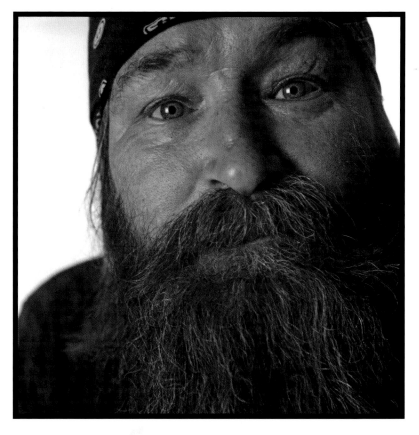
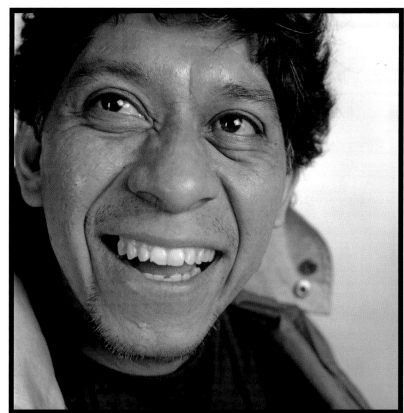
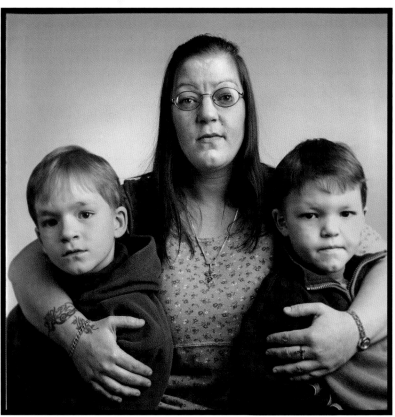
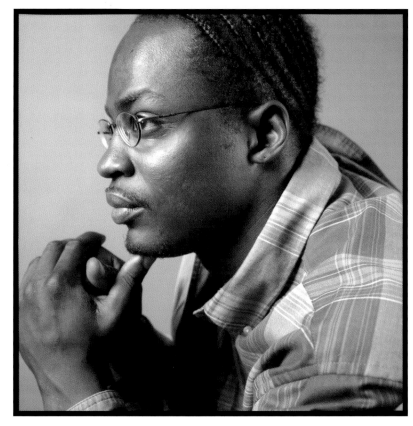

sharing & caring Hands

rian Philbrick showed up on the doorstep a few hours after Mary Jo opened her storefront for the poor in 1985. Looking like a horror movie cross between Jesus and an ape man, he was 25 years old, but seemed far older, aged by childhood abuse and years spent defending himself on the streets and rails. That winter morning he'd been working his way into downtown Minneapolis from the railroad yard, scrounging in garbage cans and scanning the sidewalk for coins. As he approached the old garment district, then a skid row of run-down stores, he saw a light in one building and watched from the street as a sweet-looking woman puttered around, making coffee, setting out doughnuts. He slumped on the concrete, afraid to go in, shy around people, but drawn to the light and warmth.

"Mary Jo opened the door and invited me in," he recalled years later. "But I pulled back, hunched into myself, covering up with my beard and my hair, so you could hardly see me." The novice helpmate, who was calling her place Sharing & Caring Hands, wasn't deterred. "Mary Jo brought me out a cup of coffee and some cookies. And she patted my hair, asked God to bless me. The next day I went back, and the day after that. Mary Jo and I, we'd talk." Severely abused as a child, he said he'd run away from his Boston-area home at 15 and lived in the woods and on the rails for 10 years, unable to function in society. "Mary Jo showed me a different way," he said, stopping to catch his breath and wipe his eyes. "Mary Jo changed me. I used to fight a lot. Somebody would say something I didn't like, I'd slap them. Usually I'd end up in jail, or I'd go to the railroad tracks and catch a train out of town real quick. I got to the point where I didn't care if I lived or died, but Mary Jo changed that. She'd talk to me. She'd tell me I shouldn't be fighting, that it hurts people. I'd get so mad and Mary Jo would say, 'Look at you, now look at you, now you're all angry.' And I was. I was real angry. Me and Mary Jo would pray. After awhile, I started believing what she says, that she loves me. And I love her too. Now I'm glad to be alive. I try to do good. It's kind of a miracle."

Once unable to talk to others, so frightening in appearance and manner that people would hurry across the street to avoid him, he became a gentle-looking, sweet man, with a shy smile. Living on disability, he helped out around Sharing & Caring Hands and lived in a bungalow that the Copelands found him a few miles away. When he died in 2001, 16 years after he showed up at Mary Jo's door, he was 41. "I think he just wore out," she said at his memorial service. "He'd had a hard life, a very hard life."

Low wages, a lack of affordable housing, family dysfunction, alcoholism, drug addiction, and mental illness all drive people to seek Mary Jo's help. "People come and say, 'I can't read. I can't write. I've been sexually abused. I've been beaten,'" she notes. "There is so much pain and alienation in this world. People are begging: 'Hold me, hug me, pray with me.'"

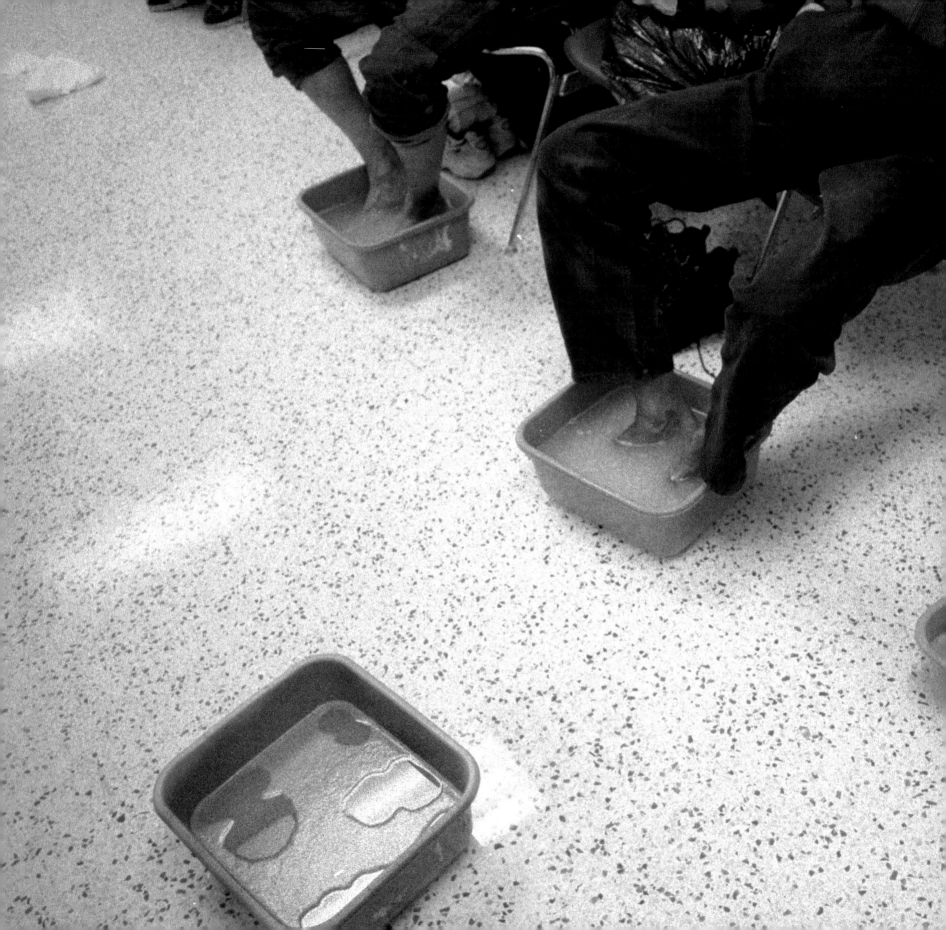

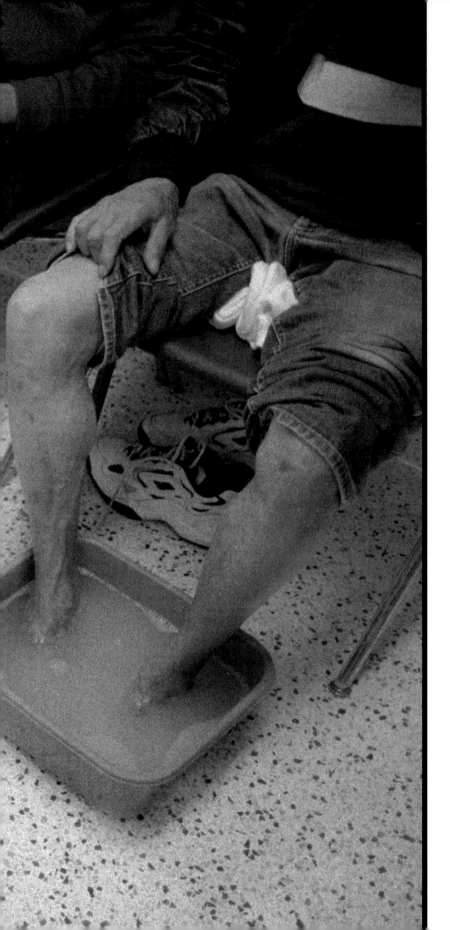

"Look after your feet; they must carry you a long way in this world and then all the way to the kingdom of God."
—Mary Jo

Critics call her crazy, mercurial, self-promoting. Fans—from those she's helped to volunteers and donors—call her a saint, an angel, America's Mother Teresa. But Mary Jo Copeland shrugs off the labels, good and bad. "I guess people all have their perspective," she says. "Some of the comments are hurtful, some make me feel humble. But in the end I don't care too much what anyone says: I have to focus on my work. I have to do what I think best."

Her vision is clear: to be a last-chance resource for the poor and homeless, a safety net for those who are falling through society's cracks. At a time when resources for the poor are continually dropping and government officials are calling on the private sector to take a larger role, Mary Jo is not only providing one-on-one assistance to the poor; she's also creating a model for others who want to make this a kinder, better world.

She's not doing it alone. She has help—up to 1,000 volunteers in any one year, hundreds in any particular week, plus at least as many financial benefactors. But it's her vision. She's the catalyst, the central force. "She runs the show. She's cracking the whip," says Tom Lowe, CEO of a Minnesota lumber company, and a major donor.

Every morning and afternoon, Mary Jo gets on the loudspeaker and asks people who want their feet "soaked" to come to a semi-private area off the dining room. Emulating Jesus, she washes the worn and callused feet of the poor, then gives them clean socks and new walking shoes. "It's what I am called to do," she says. "To touch the poor, to get on my knees to them."

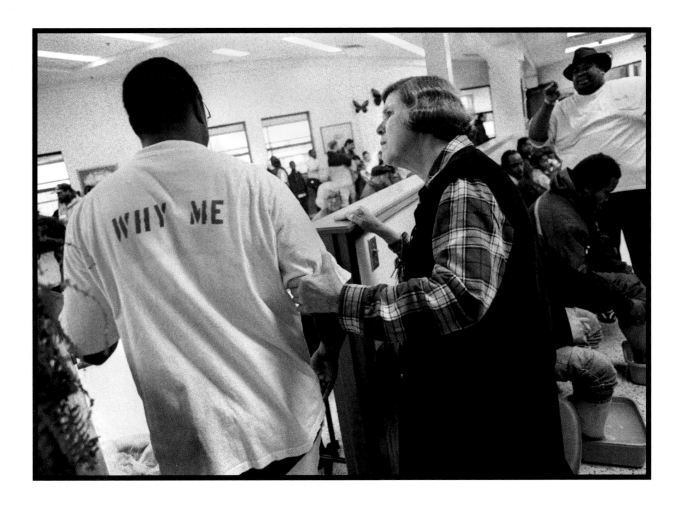

After overcoming her internal traumas and bringing up a dozen children, Mary Jo says, "It's nothing, a cakewalk" running a $4 million outreach for the poor, raising $19 million more for buildings and land, being the inspiration and hands-on hub of a charity serving hundreds of people a day. But she constantly gives credit to God. Thinking back over Mary Jo's life, then looking at what she's accomplished for the poor, her son Mark says it's enough to make even the most jaded believe in God. "In a way you can see with my mother that God can work through anyone," Mark notes. "Anyone who truly loves God and wants to serve the poor can do it. How else can you explain all she's done? No one human being could have managed all this. She talks to 500 people a day, doing what she can for them. She serves 1,800, maybe more, people a day—meals, shoes, the food shelf, housing,

ABOVE: *Many of her clients are regulars, stopping by for lunch or a chance to chat with Mary Jo. "A lot of them are like my children," she says. "I've known them so many years, I've seen their ups and downs."*
RIGHT: *"You wonder how some of these people can even walk, their feet are so sore," Mary Jo says. "Most people in the world wouldn't believe it. We take so much for granted."*

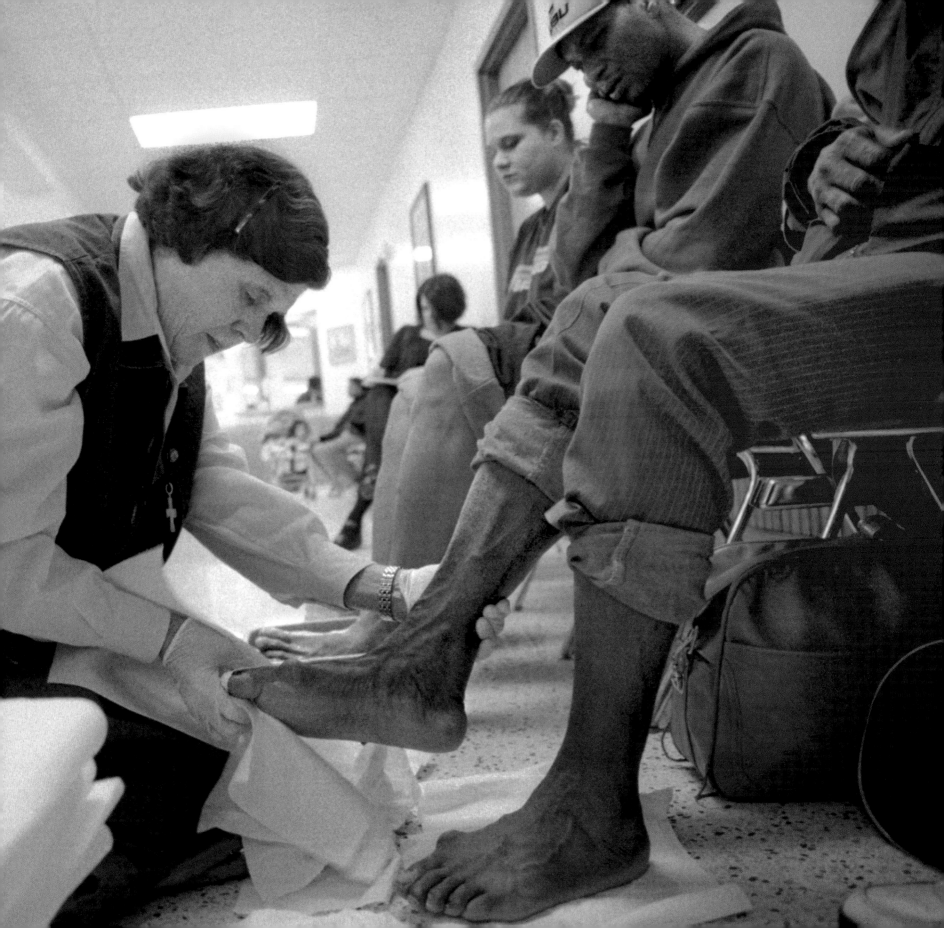

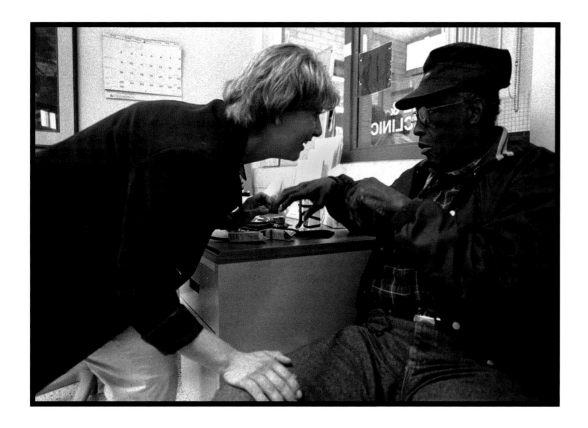

whatever they need. She washes 15, 20 pair of feet a day. Plus, it's always growing—more people to be served, more ideas about how to do it: transitional housing, the day care center, the teen center, now an orphanage. And it all comes back to my mother who had such a hard life, had so many problems."

Photographers always want to catch the washing of the feet. Great television. Great candid photos. The public relations and fundraising value isn't lost on Mary Jo, but she kneels on the floor, massaging swollen and bruised feet, whether or not the cameras are around. She says it's the heart of her work with the poor, a daily reminder that she's trying to emulate Jesus. "I'm doing this in memory of Him. That's why I wash feet," she tells a visitor, gently removing filthy socks from an elderly vagrant. "We are commanded to be servants of the poor. And what better sign

Perry Peoples, 70, has long been a favorite regular at the medical clinic on the lower level of Sharing & Caring Hands. Articulate and polite, Peoples says a domestic dispute combined with "dirty politics" left him with no money for his final years. He sleeps in a van in a city alley: "Unfortunately, I can't do any better. I'm always trying. There but for the grace of God go all of us."

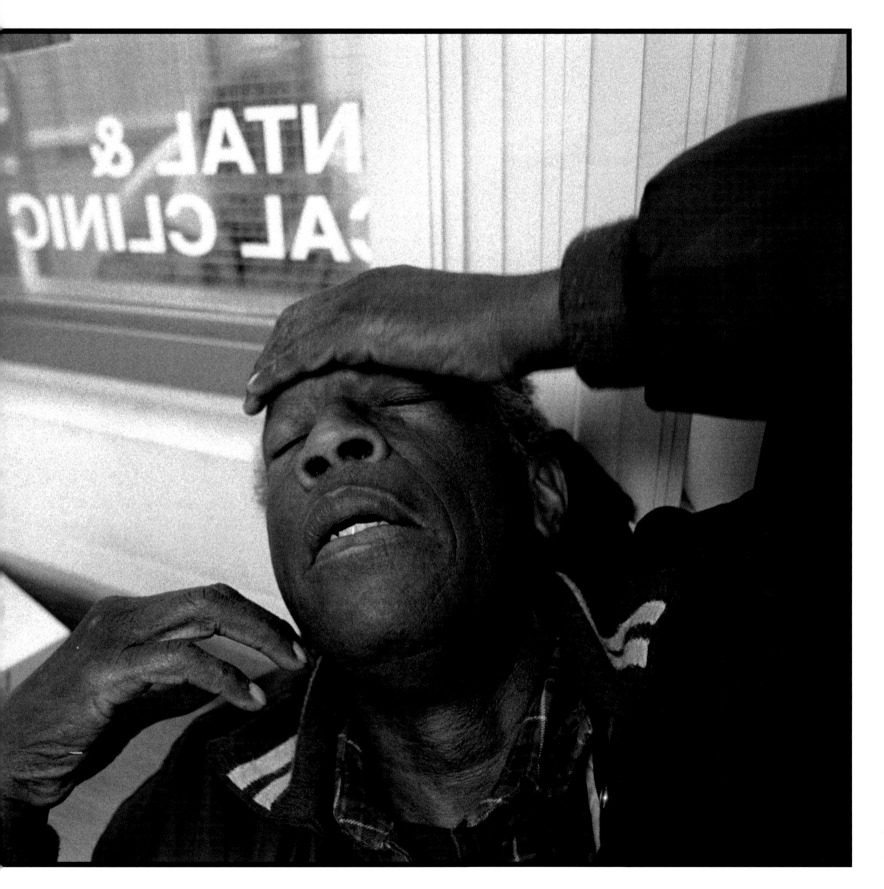

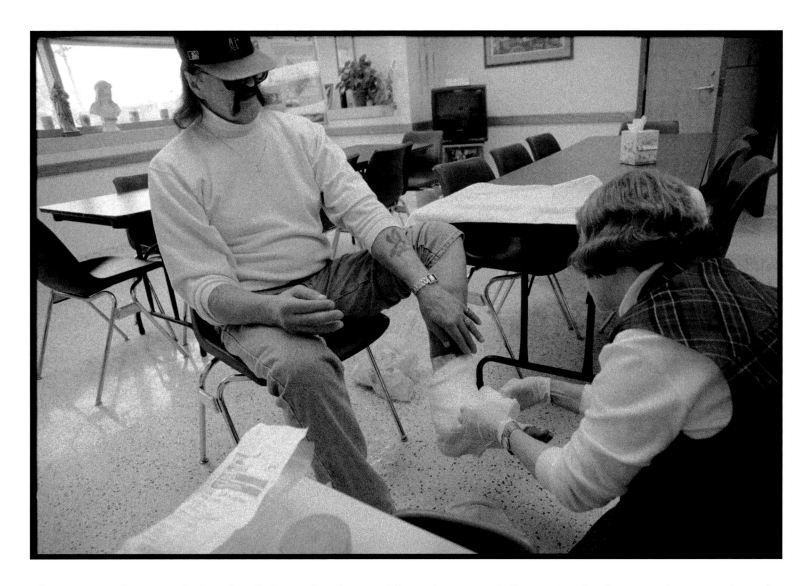

of our serving than to wash their feet?" She washes dozens of feet a day as people line up just for that attention. Sometimes she chats at length with the people as she rubs ointment into their bruises; other times she massages with the distracted air of a mother of 12, her mind rushing from one thing to another as she goes through the tasks of the day. Whether mindful or distracted, she says the hands-on work has increased both her faith and her need for it. "My need of God becomes greater as my work becomes bigger. You have to have silence and solitude to be renewed and refreshed. I've never been meant to be in a social world. I'm a pretty private person. I believe God saved me for Himself. If I'd become a worldly person, I wouldn't have had time for God."

Worldly or not, she clearly revels in the spotlight. At the shelter, she's the focus of attention, affection, even adulation. The cynical may see some self-interest in the ongoing chorus of "I love you, Mary Jo" and "God bless you, Mary Jo" from the people she

The medical and dental clinics, staffed part-time by county nursing assistants and volunteer dentists, run on a first-come, first-served basis. "These people don't have insurance. They don't have a family doctor," Mary Jo notes. "For some, this is the only medical care they get."

serves, but the same level of regard also fills the volunteer ranks. Former CEOs chop vegetables in the kitchen; former clients stack chairs after lunch—all speak of her with a candid appreciation of her mix of humanity and faith.

Those who see her work up-close also note her confidence and determination, even a decidedly stubborn streak. She doesn't take government money and refuses to be part of the United Way, determined, she says, "to work by my rules. I'm here in the trenches. I'm not some bureaucrat." She threatened to sue the city when they tried to stop construction of Mary's Place, her transitional apartment building. "The city said they didn't want people living here, in the shadow of the county garbage burning plant," Mary Jo scoffs, noting that city officials didn't offer any other ideas on land sites. "They'd rather have the poor on the street than in our nice building. It's a power thing, doesn't make sense. They don't like that I don't have to answer to them. We serve the poor and homeless, not the powerful."

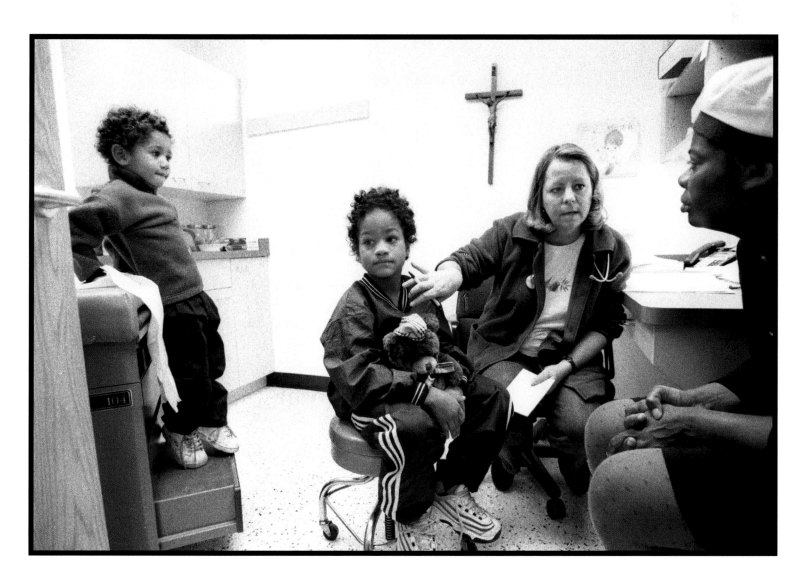

35

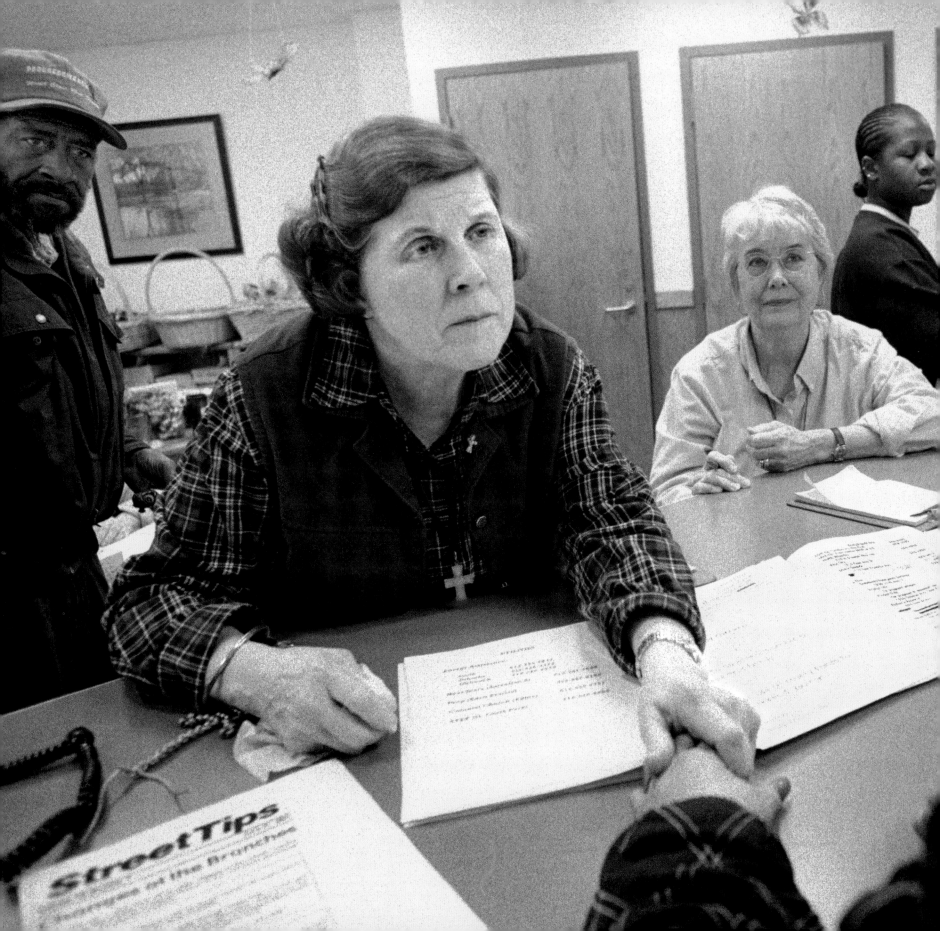

Antonio Cardinelli, 48, laughs to think of Mary Jo Copeland kow-towing to the rich and powerful. He's been helping her ever since he met her out back of Mousey's Bar in 1984. He was a bouncer; she was handing out sandwiches and socks from the trunk of her car. Circumspect about his personal circumstances, he's one of several full-time volunteers, most former street people or recovering addicts on disability, who help Mary Jo in exchange for modest housing and cigarette money. Huge, with a flowing black handlebar mustache that makes him look like a bandit in a western, he sticks close to Mary Jo as she works the line at Sharing & Caring Hands, talking with peti-tioners who line the dining room wall, waiting to ask her for help. "I do everything with her, whatever it is," he says. "It's not really protection, though I was a bar bouncer. She can handle herself. Sometimes she likes someone to talk over a decision with. Don't get me wrong. She makes the decisions. But she likes to discuss it sometimes." Streetwise and quick to spot a phony, he says he was won over years ago by what he calls Mary Jo's goodness. "She amazes me every day. Her work just keeps getting bigger and bigger. For the poor and home-less, there's no one like Mary Jo."

Dealing with dozens of people in rapid succession, she makes decisions quickly—sometimes with tears or a smile. ("Oh, look at this little sweetheart," she says, kissing a baby on the cheek, reassuring his mother, examining the lease she's brought along. "We can help with the rent. We don't want you to lose your apartment after two years of living there.") Sometimes there's a cool, even gruff, send-off: ("We don't pay telephone bills," she tells a robust-looking young man. "You can get a day job and earn that. That's what I told my kids: Get out and work, earn your way.")

The line of people seeking help forms early most weekdays, with dozens, sometimes a hundred or more, hoping to speak to Mary Jo personally about their need. Many are return visitors and know she requires verification, usually in writing, before helping with rent deposits, work clothes, or other cash outlays.

"Each one of us must be bread, broken and given, wine poured and shared." —Mary Jo

She asks questions, looks into people's eyes, reviews their paperwork. Listening carefully, her hand on his shoulder, Mary Jo commiserates with a tiny elderly man who needs bus fare to his uncle's funeral in New Orleans. "Bless you," she says. "I'm so sorry your uncle died. Were you real close to him?" But then, as the man cries, mumbling his affection for his uncle, she explains that she can't give him the bus money. "I can only do transportation to the funerals of immediate relatives—your mother, children." The man perks up: "Oh, I forgot to mention: my mother died too. They both died—my uncle and my mother." Without missing a beat, Mary Jo takes his hand in hers and reaches out to Antonio and others standing nearby. "You poor man, let's pray" and she launches into a litany of prayers. Then she sends him off with a volunteer who will call the funeral home, try to verify the deaths. Mary Jo

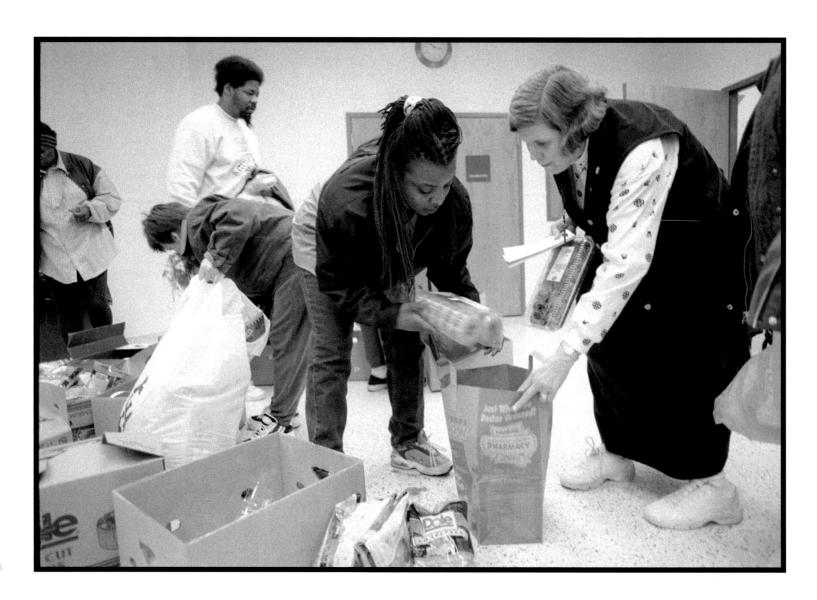

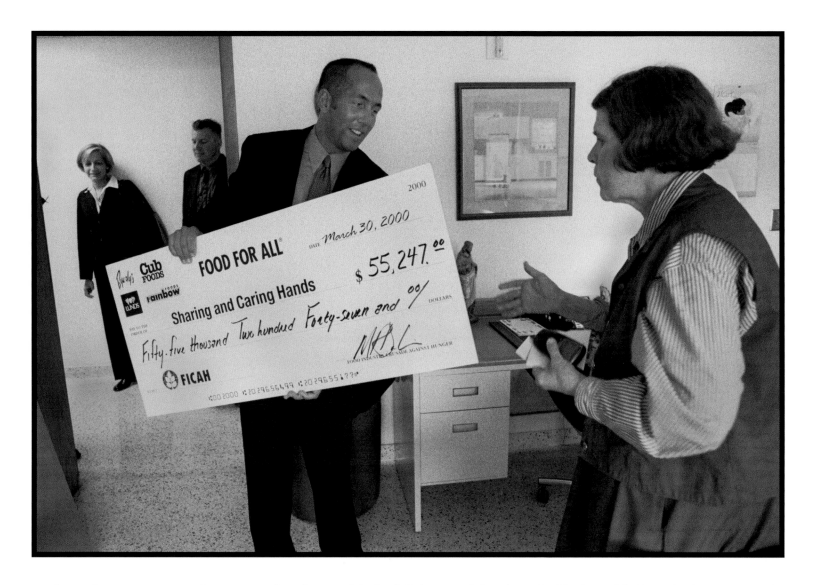

smiles. He's not putting anything over on her. "He won't be back," she says. "There's no double funeral." Then why the prayers? She winks: "Prayer never hurts. Prayer never hurts."

As she turns to the next in line, Antonio grins. "She may get ripped off now and then, but not often. She's very sharp. She's got street smarts. Plus, she'd rather make a mistake, and help someone who doesn't need the help, than turn someone out who has no place else to go. She's not too proud to make a mistake."

Petitioners, clients, return often—sometimes for more help, often to volunteer, now and then just to say thanks or to share a prayer. Lance Bowie, 44, a security worker at the nearby Target Center sports arena, met Mary Jo in 1996 when he was new to town, without work or housing. She prayed with him and gave him money for work boots. Several years later he patiently waited his turn to thank her. "Ever since Mary Jo prayed with me, things have been good. I've only met nice people. I got drugs and alcohol out of my life." He gave her a hug. "You are beautiful. It's where I

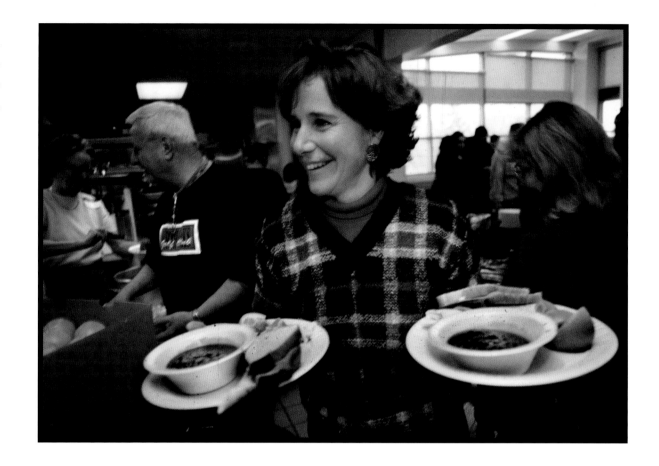

started my new life. I didn't forget you. I have a job and I still have those boots you bought me. God bless you."

Mary Jo says she's seeing more and more families in need. "It's getting worse and worse. So many people who can't make it, who don't know what to do. When I started this work, it was mostly men, single men. Then a few women, maybe a mother or a father would come needing help with the rent or a medical thing for the kids," she recalls. "But now it's the families. Still the single men, some single women, but more and more mothers with children or two parents with the children. They might not have the education, they might have addiction issues or health problems, and they can't make it—they can't find jobs or housing or they're just overwhelmed, their spirits broken."

Her often-affluent volunteers are as loyal as her former clients. Cappy Moore, 49, a vivacious homemaker from a posh Minneapolis suburb, once spent her days playing tennis and volunteering at her children's private schools. Then she met Mary Jo. "I used to play tennis all the time. I was into that lifestyle; it's an affluent area," Moore recalls. Before becoming social justice director of her church, Moore volunteered several days a week at Sharing & Caring Hands, plus more time at home writing grant requests. She still plays tennis on Wednesday mornings, "but it feels so empty. Mary Jo's work affects my whole life, my whole family. I suppose I could be helping out at the science fair at my kid's school, but I think the best way to be a parent is by being true to yourself. Your kids see that."

Volunteer Cappy Moore has introduced dozens of friends and neighbors to Mary Jo's work. She's now involved with planning for the next project: a children's home.

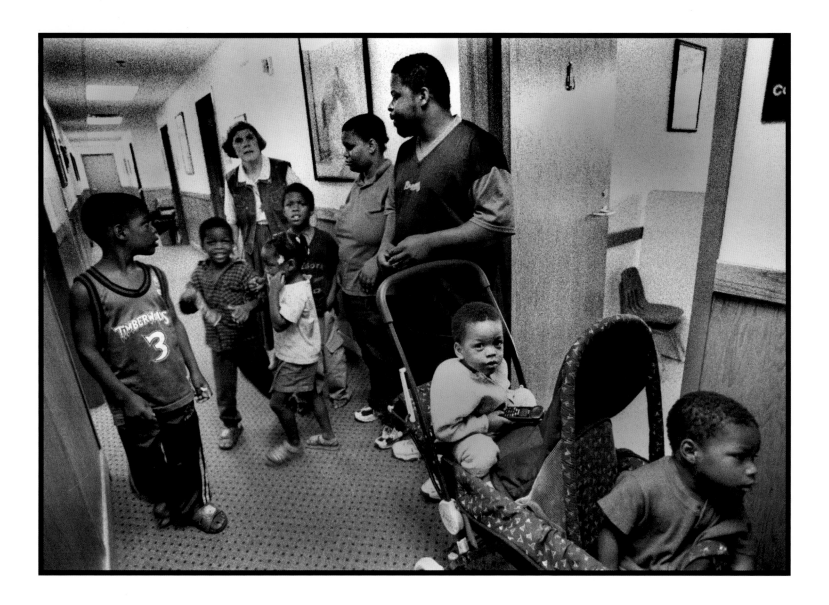

Married to a Northwest Airlines pilot, mother of six, Moore brings her wealthy neighbors and friends to see Mary Jo's work. "That's the best way to move people, to let them see what's going on just 15 minutes down the freeway from our houses. They leave sobbing. It's such a different world. You go home to your comfort and think about the people you've worked with, the family who lived under the bridge before Mary Jo took them in."

Moore's friends know that she's after their hearts and their money. "I'm real upfront about it," she jokes. "My mission is to empty their pockets and open their hearts. I bring them down, they see, and they're moved." She cases dinner parties for likely prospects. "You go to a party and you hear things and your mind starts clicking," the outgoing Moore explains. "Maybe you

Mary Jo is particularly sympathetic to families who are hit by unpredictable problems. This young family had settled into a duplex, only to be the victim of a drive-by shooter; worried about the safety of their young children, they quickly packed up what they could and sought shelter with Mary Jo.

"*Everything we have, every breath we take, is a gift from God.*"
—*Mary Jo*

follow up the next week. People don't mind. They're so good. The money comes in, so that it can go back out."

Working in an office a few feet away from Mary Jo's, just off a waiting area usually filled with parents and children, Don Monroe sees the money going out. A retired insurance agent who has dedicated the rest of his life to helping Mary Jo, Monroe, 64, is impressed with her approach. "You want some-one who can make decisions fast and without worrying about the bureaucracy or the rules and regulations," he notes. "Mary Jo doesn't take federal money. She's not beholden to any other charity or organization. She makes decisions based on what's best for the people she serves." Monroe says the decisions aren't made willy-nilly or arbitrarily. "She prays for discern-ment. She walks closely with God. That's why everyone trusts her—the people she helps, and the people who help her with their time and money."

He scoffs at people who criticize Mary Jo for driving a late-model white Lincoln Continental, a gift from her husband and her only apparent luxury. "I've been here several years and she's never taken a vacation," Monroe notes. "She spends nothing on herself and they could obviously be living very luxuriously. I'm sure Dick's work paid six figures for a long time." (In 2001, Dick left his executive position with a local grocery chain and began working full-time at Sharing & Caring Hands; he draws a $65,000 salary. Mary Jo considers herself an unpaid volunteer.)

The main entrance to Sharing & Caring Hands features a statue of Jesus and the inscription from the Statue of Liberty. "Jesus could have written those words on the Statue," Mary Jo says.

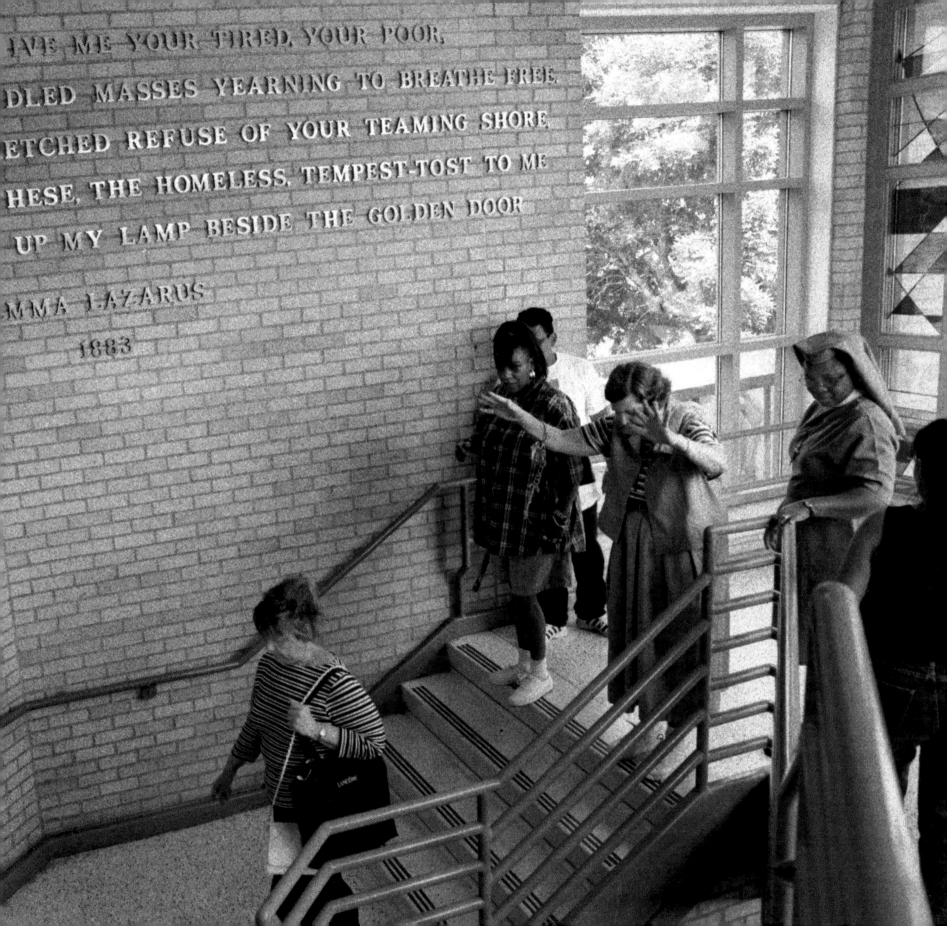

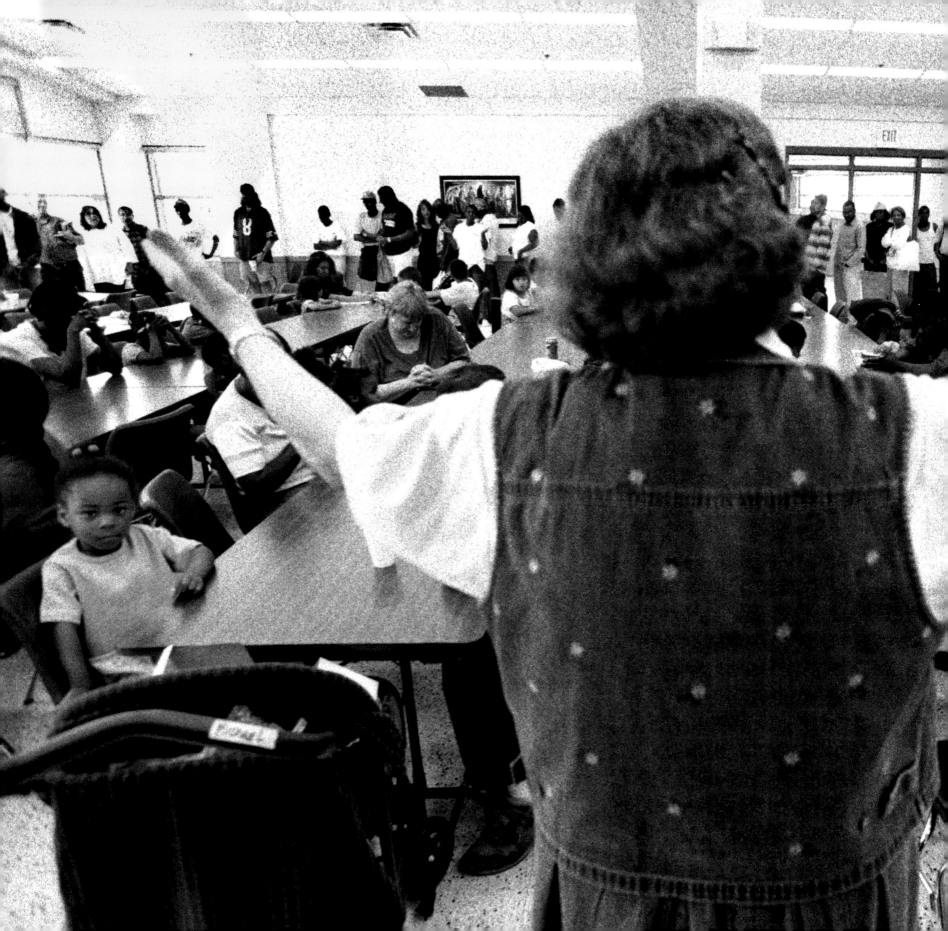

let's pray: God, help me to go to work if I'm able. God help me go to treatment if I need to. There will be an end to pain and sorrow." She ends as abruptly as she began, clapping her hands, skipping across the front of the room, shaking her full skirt and breaking into her favorite song, "If you're happy and you know it, clap your hands."

The poor, lining the walls as they wait for a hot meal, respond with varying degrees of enthusiasm and join in, some begrudgingly, some shaking their heads in wonder and bemusement. Elderly men put down paper bags stuffed with clothing from the room downstairs; women hush their babies; volunteers stop in place. It's a bit bizarre, this older woman in the denim skirt, dancing around, clapping her hands high, singing at the top of her lungs. But Mary Jo smiles, hoping that her own joy is contagious. "I used to be so unhappy, so alone," she tells a visitor a few minutes later. "Now I'm happy. I'm all I'd ever hoped I could be. And I want to share that."

Watching from the sidelines, Jack LaVigne keeps his eye on the crowd as a foot-tapping Mary Jo sings. A retired Minneapolis police officer, he says he's a skeptical guy, no one's pushover. But don't underestimate the power of that singing, the power of those prayers, he tells visitors. He's been around Mary Jo since 1989 and he knows their impact. "You'll see people coming in drunk and then one day they'll say they're going to treatment. Or they get a job, get on their feet," LaVigne notes. "These people

She's usually the one leading the prayers, but every so often a visiting church person will take over, asking God to bless Mary Jo and her work. "It's humbling," she says. "God is working through me; I'm not doing this on my own."

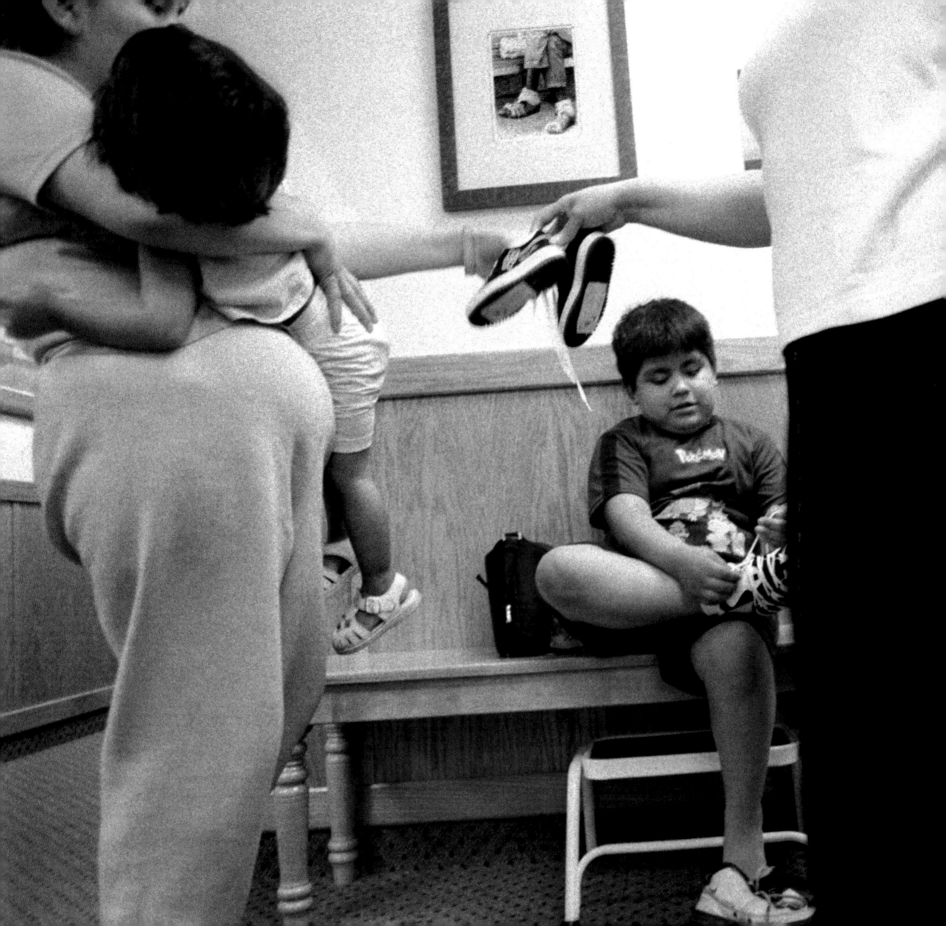

*"Simple acts of love
make a great difference.
Be Jesus in this world."* —Mary Jo

have a lot of respect for Mary Jo Copeland. She helps people, the ones who legitimately need it." A burly man who is sometimes moved to tears by what he sees at the shelter, LaVigne says newcomers, new clients off the streets, sometimes scoff at Mary Jo's prayers. "But then they see she's real sincere. She really does pray for people. She believes God will help them. Once people see that, there's no making fun."

Whether it's the prayers or the welcoming environment, there are few problems as people wait for help or dinner. "Mary Jo doesn't tolerate fights, drinking, or drugs," LaVigne says. "This lady does a wonderful job. There's nobody else that does this kind of work. When Mother Teresa died, I think she passed the baton to Mary Jo."

Mary Jo and her volunteers give out dozens of pairs of shoes and socks a day. "Some people come to have their feet washed, and the shoes and socks almost stick to their feet. The shoes are so old and worn," she observes. "It makes a big difference to people, to their feet and their spirit, to have fresh, comfortable walking shoes." In addition, poor parents often have trouble keeping their fast-growing children in shoes that fit, so they ask Mary Jo for help.

"What is success? It's remaining faithful to God's will. And what's God's will? To love one another." –Mary Jo

José Valadez, 33, a legal immigrant from Mexico, found Sharing & Caring Hands shortly after moving to Minnesota from California. "I talked to Spanish people who lived here for a long time. They said, 'Go to see Mary Jo. She has clothes and shoes. She's nice people.'" He said he was most grateful for a hearty lunch and the use of a free phone to look for day work. "In California, I could only find jobs that pay $5 an hour; you can't live on that. Here if I can find a job, I get paid $9 an hour." He stayed at the Salvation Army shelter from 6 p.m. until 6 a.m. but, like many poor people, was at a disadvantage when looking for work. "I have no phone number and I have no address, so it's hard to find a good job. I want to get a job and a place to live. I don't want to be always walking and walking. I want to send for my wife and my son, but first I need a job and a place to live."

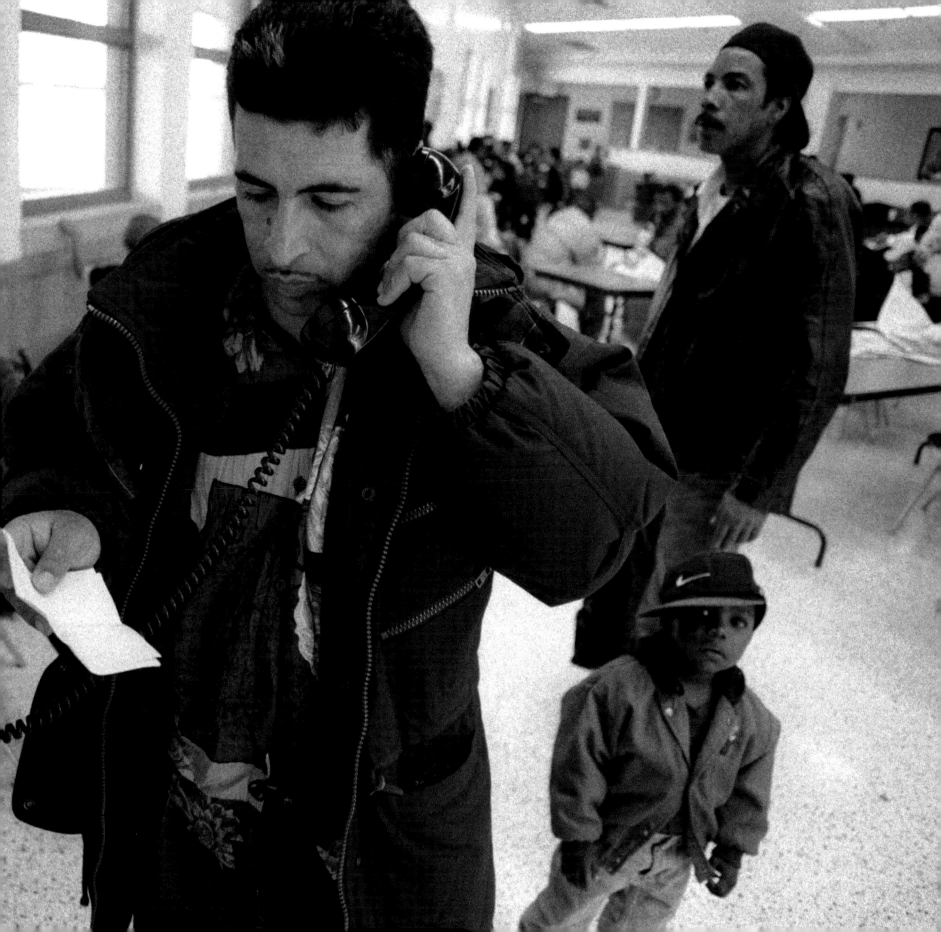

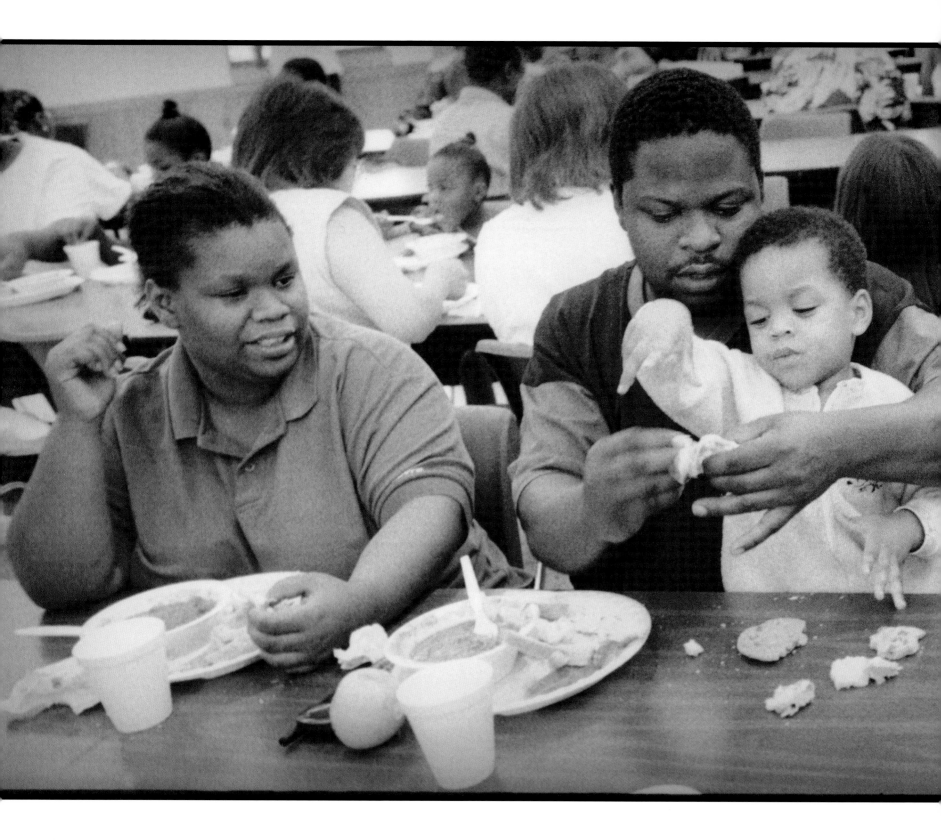

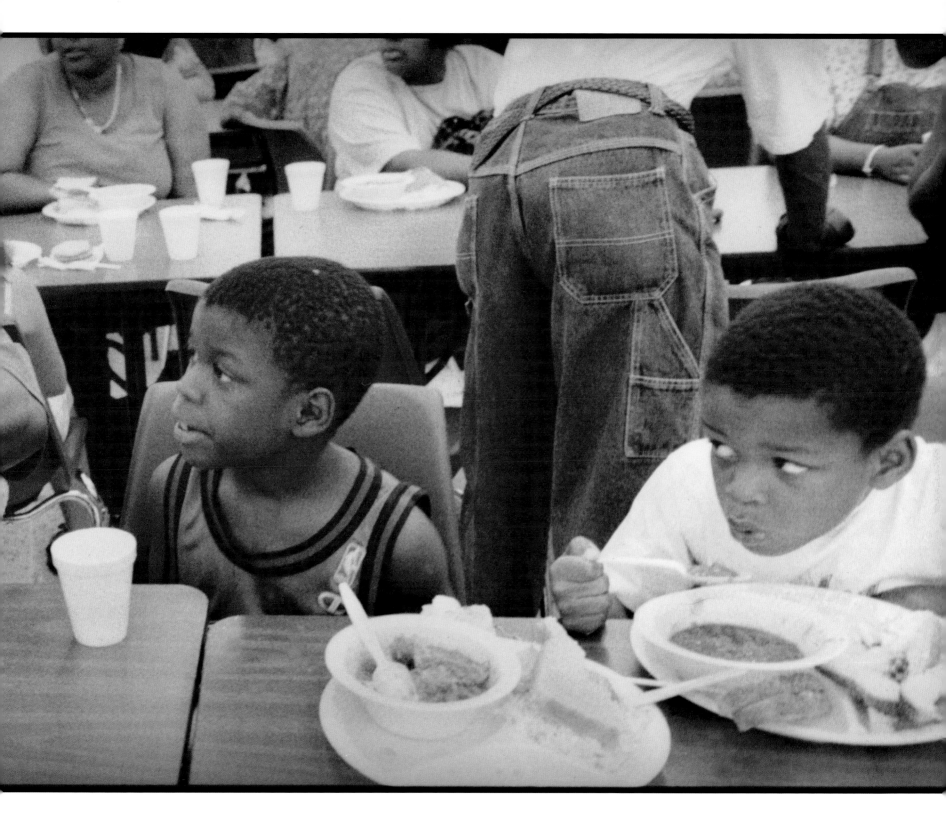

*"Give people a chance to rest their spirit.
Then miracles happen." –Mary Jo*

dennis pathode

"I've allowed my drinking to get me into trouble. Last Saturday night, I blacked out after about half a gallon of vodka. I came from money, but here I am at Mary Jo's. She does a lot of good, but she's human too. I come here to eat, to have coffee, to see the nurses when I need to. I'm a singer, country. I play the guitar. Or I used to. Maybe some day I will again."

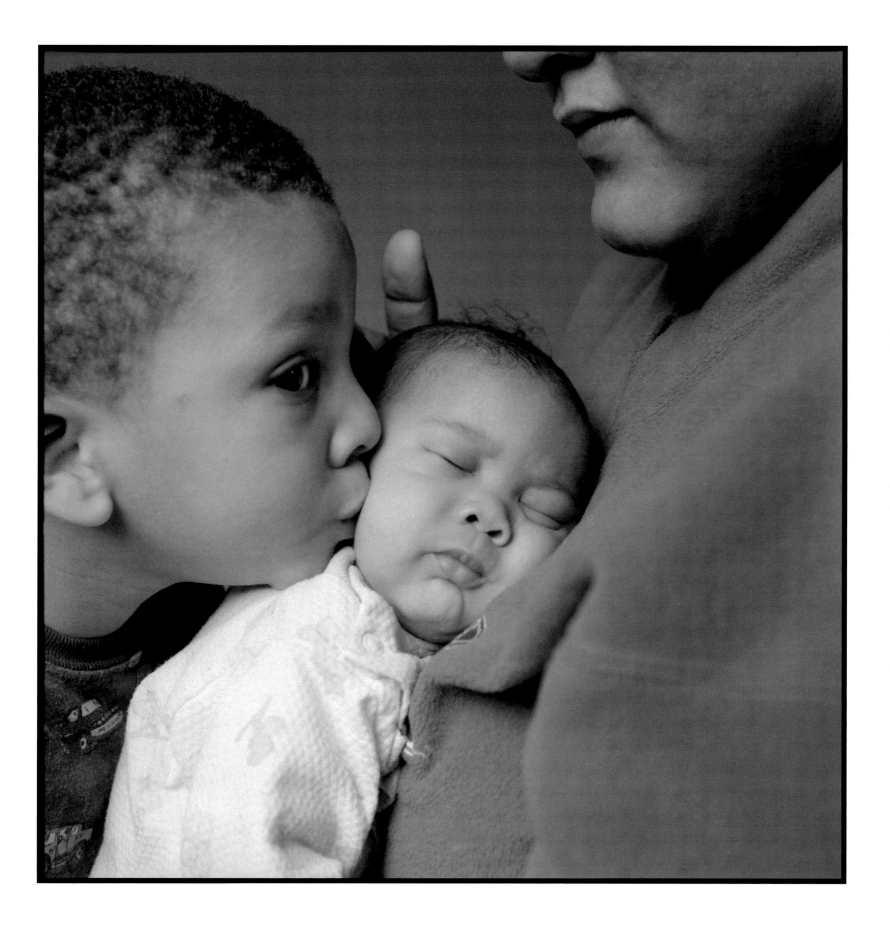

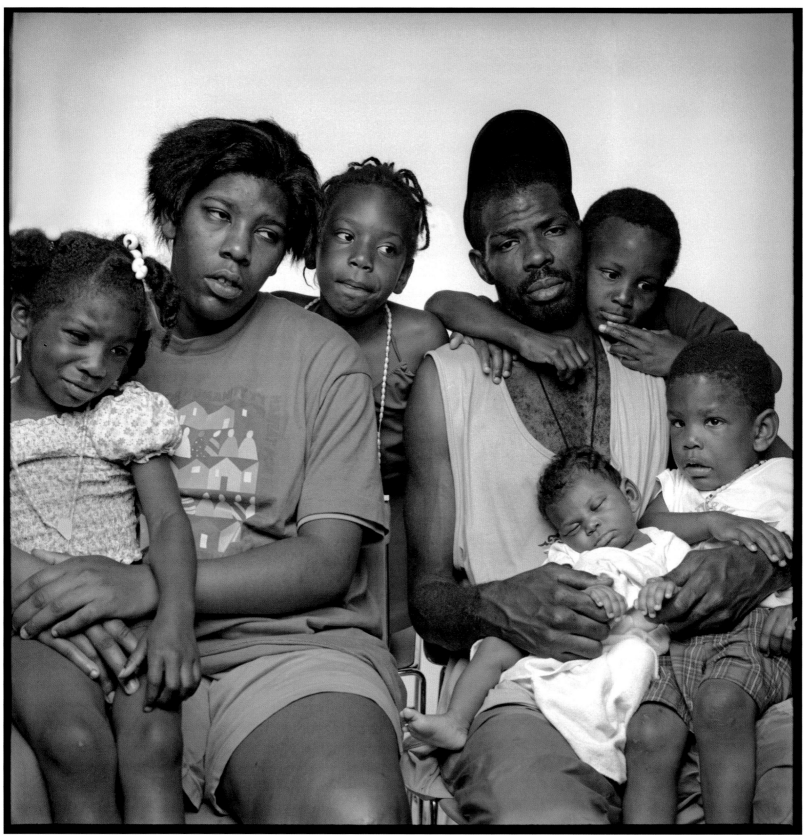

"We came here yesterday for the first time. Hennepin County sent us away; they wouldn't help us. I'm just 22 and my man—we aren't married but we've been together six years—is 31 and we have all these children. The baby's a month old and the oldest is five. We was living in a place but the lease was up. Then we went to our family, but they put us out. He's getting training to work in construction. I've done some housekeeping and fast food work. It's hard to find housing, even with Section 8. I get welfare but it's only $619 a month and I've used two of the three years. I'm making a goal to go to school, but it's hard when you have all these children. I called the shelters, but they didn't have room. When I called Mary Jo, she said to take a cab and she'd pay for it. When we got here, she gave us food and an apartment and said if we're here more than 30 days, that's fine."

debra powe

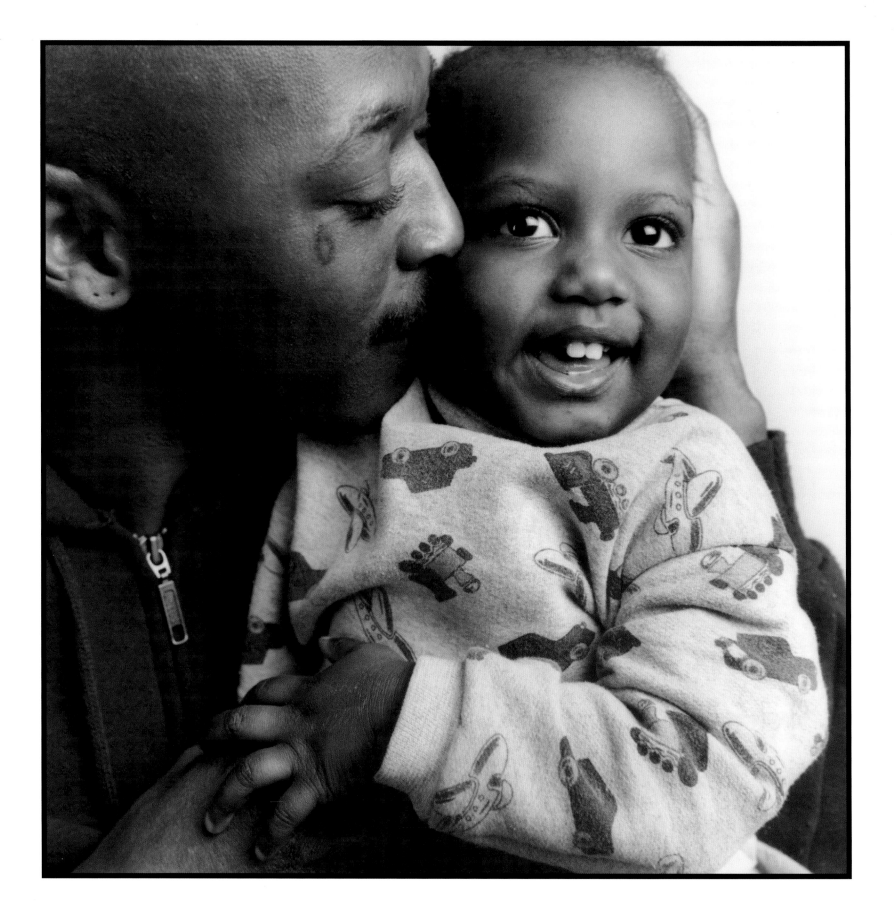

"I got sick on my job and the people there wouldn't help me. My feet were getting blistered up and bad, so I decided to come here and get them soaked. A friend told Mary Jo about my employment situation, and she said I could help her out. I'm not an employee but I help clean up the areas and help with security and Mary Jo helps me, puts me up in a room with some others."

leonard hollings

"I work for the *Star Tribune* on Saturday nights, stuffing the comics. And my mother recently died so we're trying to clean up her house and I'm living there until it's sold. I used to be a computer programmer in the seventies and eighties, but I got burned out. Know a lot of places to get free things, so that cuts down on the bills. If it weren't for a place like this, a lot of people would have no place to go."

terry belcher

"My mother died April 4, 1995—when I was 27 years old. I was very upset; I had a nervous breakdown and was homeless. I didn't know what I was going to do. I broke my leg getting off the bus, so I was in real bad shape. I came to Mary Jo. When I first landed at Mary Jo's doorstep, she had someone take me to Target. We walked through the store and she'd say, 'How about this? How about this?' I cried the whole time. I was so grateful.

"Mary Jo helped me get a little apartment and got me a bed and a table and couch, and little curtains, and pots and pans. It's real nice. She encouraged me to go to day treatment. She's done so much for me—bought me clothes and tennis shoes. She paid for half of my air conditioner. She gave me a little volunteer job so I'd feel good about myself. She even told me to start going to church; I was baptized but I'd stopped going. Dick and Mary Jo sponsored me for my first communion in 1997. I'm not all the way better yet, but I'm getting stronger and stronger. If it wasn't for Mary Jo, I probably would have killed myself. Even now, sometimes when I'm so depressed, I just want to come here and feel love—breathe in love."

jennifer anne justen

"It's tough to be a homeless father with your kids. Right now we're staying at a motel. It's a very hard road for fathers."

thomas
williams

"I've been homeless almost six years. Nobody will rent to us because we have bad credit. We live in a tent in the woods down south of town—no one even knows we're there. We come to eat here, maybe three times a week. Sometimes for health care; I have trouble with my arms and I've had hernias. A lot of people would go hungry without Mary Jo."

patricia
kendell

"My given name is Diane Deragon but I've been called Thumper since I was little. It's a nickname. I'm from Chicago, the West Side, but I came here with my mom 23 years ago, when I was 18 or so. She wanted to get out of Chicago; she thought it was too dangerous. I dropped out of high school and worked on and off. I

moved around a little–California, Tennessee–but came back here 12-13 years ago. My mom and I don't get along; I've got three brothers but I don't see them either–two work, one's in prison.

"I come here to Mary Jo's to use the phone and just to hang out and say hi to everyone. I come when I'm hungry and want to see my friends. I feel safer here than on the street. I stay outside, up toward the river. I climb up under the bridge. In winter, I stay in abandoned cars in the junkyard. In Minnesota, the only thing you really need is mosquito repellent!

"Mary Jo helps me out; she gives me money now and then. I usually don't ask for it; I don't like to do that. I was getting SSI but they cut me off because I didn't go to see a head shrinker. I have a good life. I've got friends: Wayne's been my friend for 15 years; it's not romantic, just friends. The police are okay; they like me, I like them. I like sports a lot too and this is a great town for that; I like women's night–for $5 you can see the Minnesota Twins play. And I like to read, murder mysteries especially. I've got a library card and I get books at the library sales at Westminster Presbyterian Church."

thumper

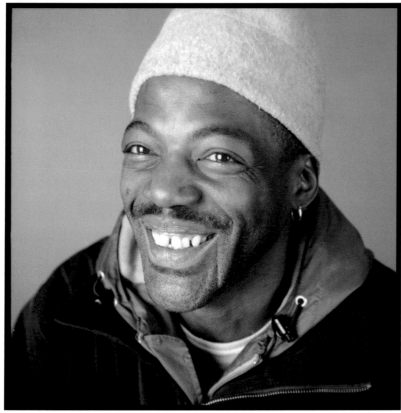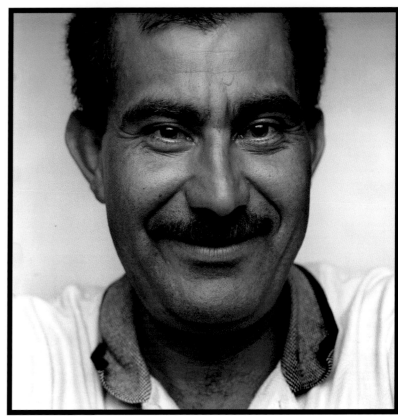

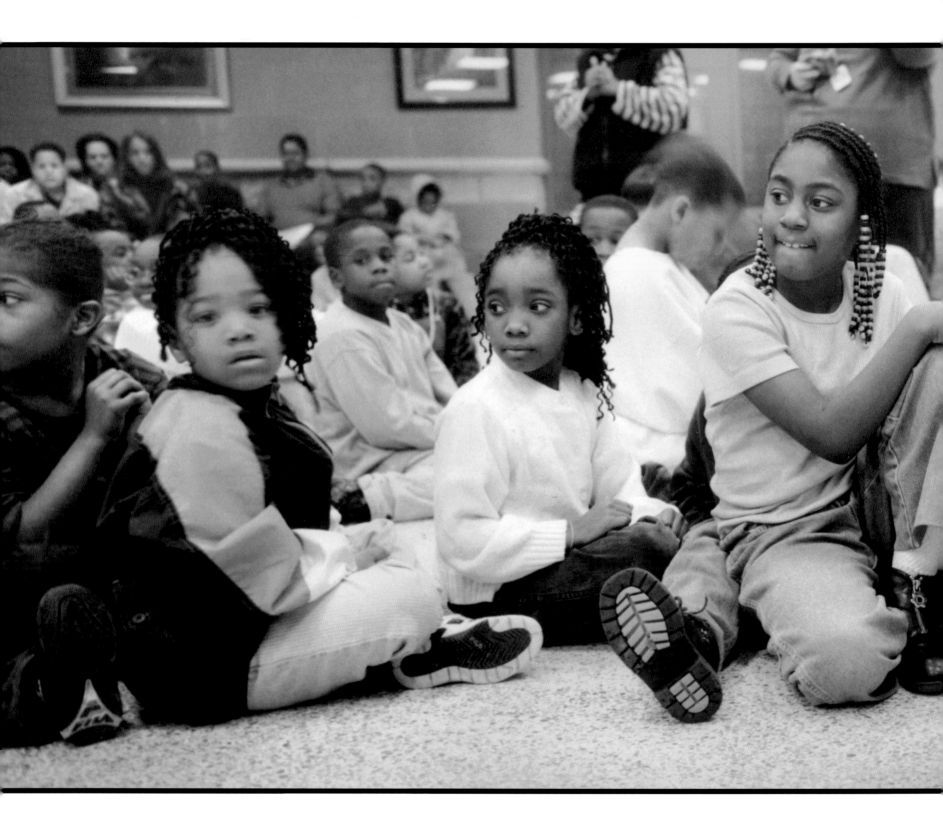

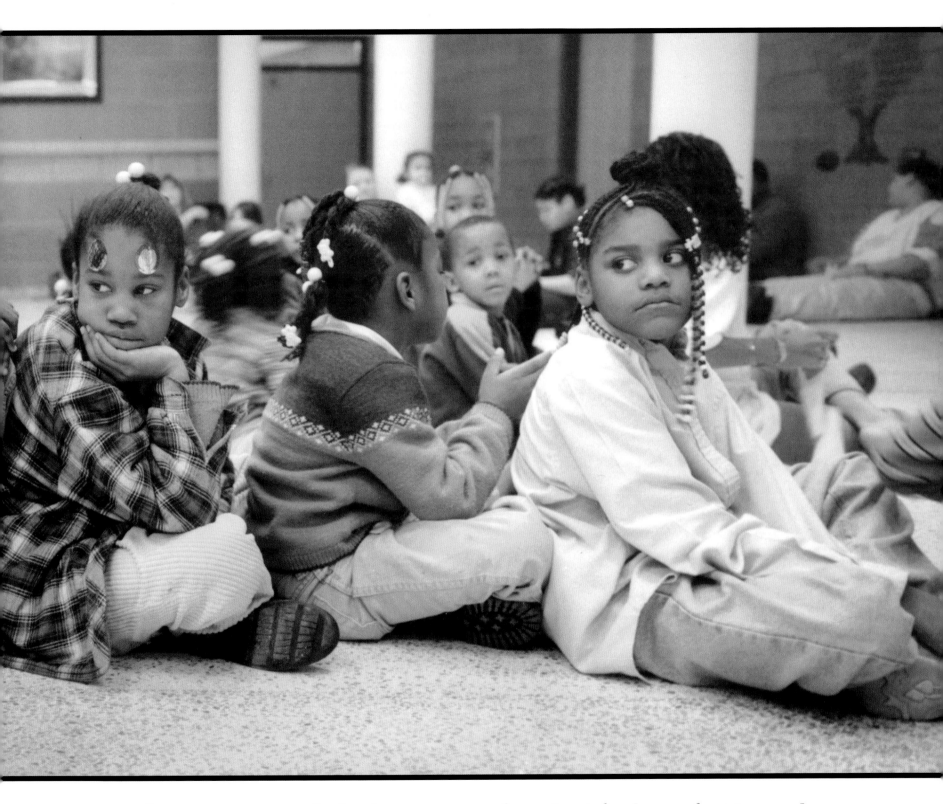

"On our journey, let's always remember: do right, love what is good, and walk humbly with your God."—Mary Jo

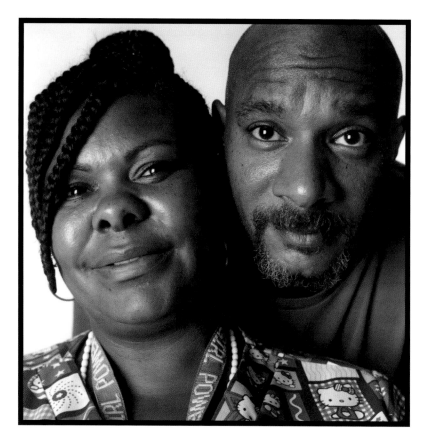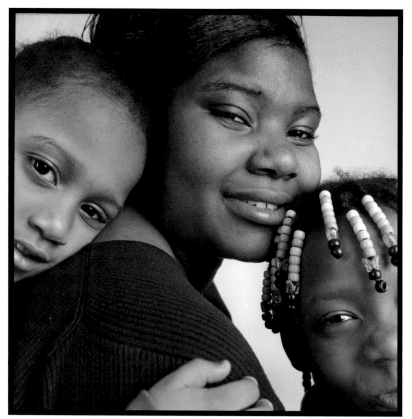

mary's place

Seven-year-old Richard is delighted to give directions to a visitor.

"Oh, Mary Jo is easy to find. Look for someone kind, and someone who is always smiling. She prays a lot too. She might be praying or singing or helping people." He pauses to look around the childcare center, to see if Mary Jo might have come in. "She's all dressed up, in a skirt-dress kind of thing. I met her last week when we moved here. She came into a big room where all the kids and mothers were, and she prayed and talked and sang and prayed. Then she had all the children line up, and she gave us each $2 and some jelly beans. She gave me a hug and asked me what I want to be when I grow up, but I just said thanks for the $2 and the jelly-beans. I couldn't think what I wanted to be."

He grins. "But tonight I'll know. When she says, 'Richard, what do you want to be when you grow up?' I'll say, 'I want to be just like you.' Not the skirt-dress thing. I'll wear a white shirt, all pressed like I'm going to church. And dark blue pants like I wear to church. And I'll pray and sing and give all the children hugs and $2 and a handful of jelly beans."

When Mary Jo started her work with the poor and homeless, she didn't realize there'd be so many mothers and children. Before she opened her little storefront in 1985, she hadn't understood the enormity of the need: women escaping abusive relationships, women addicted to drugs or alcohol, teenage girls without job skills and with more children than they can handle, women who got a bad break and need help to get back on their feet. And the children. Almost from the beginning, she saw children she wished she could take home–children who needed a loving presence, a bath, a good dinner, a safe and clean place to sleep. It was hard enough to be a single man or woman out on the streets. But it was unthinkable to be a mother with young children, and Mary Jo cried when she thought of the children.

"After a while, I knew what was going to happen to the children," she recalls. "I'd see them when they were young, maybe one or two years old, and they'd often still have a spark to them. They could smile or even laugh. But they'd come back time after time– their mothers can't cope, can't find housing or pay the bills or get away from a drunken boyfriend. And each time they'd come back, each time I'd see those children, there was a little less of a spark. It broke my heart. These are innocent children, children who deserve a happy and peaceful childhood, but they were living on the streets, under bridges, in cars, in houses without heat or food. I told Dick I had to do something."

As more and more families turned to her for help, Mary Jo raised funds and built an apartment building
across the street from Sharing & Caring Hands. "It gives families a chance to regroup," she says.
"We give them peace from the violence of the street, a chance to focus their attention on
finding work or finding good housing. We see miracles."

By then she'd moved out of the first little storefront on Second Avenue. She'd been evicted so the building could be torn down to make way for a major arena, the Target Center, and its adjacent parking. She asked Dick to sign a mortgage and bought an old building a few blocks west. Within days, she had her eye on another piece of property as well. A few hundred feet away, on a kidney-shaped remnant of land wedged between the highway and railroad tracks, Mary Jo saw the perfect place to build transitional apartments for families who had no other place to go. Across from the county garbage burner, in the shadow of the Target Center parking ramps, she built an oasis for families in trouble: a three-story, brick and glass building that feels more like a residential hotel than a shelter for the poor. Each of 92 families has its own comfortable, furnished apartment. City officials didn't like the building site, but Mary Jo was prepared to take them to court. "I wanted the apartments near the rest of Sharing & Caring Hands, so I could watch over it, so we could be as helpful as possible to these families," she recalls. "They had been living on the street, under bridges, in abusive households. This is the best place most of them have ever lived. They'll tell you that. It's safe. It's quiet. They have people to help them get

Children soon learn that Mary Jo visits them every Thursday
night. They sing songs, pray, and stand in line for
a hug, a little conversation, and $2.

"Children are resilient; they come back real fast in the right environment." —Mary Jo

their resumes together and look for jobs. People who can watch their children while they go out to find an apartment." She called it Mary's Place, after the mother of Jesus, and told residents it was a place to rest their souls, to prepare for better lives than the ones they'd known.

But Mary Jo wasn't through building. As the need increased ("The people just kept coming, more and more every day," she recalls. "And they needed more and more things"), her ambition to help kept pace. Outgrowing the drop-in shelter, she bought land across the street and in 1997 opened a 27,000-square-foot building to serve meals and provide services—medical and dental care, clothing, a food shelf, showers, and Mary Jo's one-on-one care. She converted the old building into a day care and teen center for the children of Mary's Place.

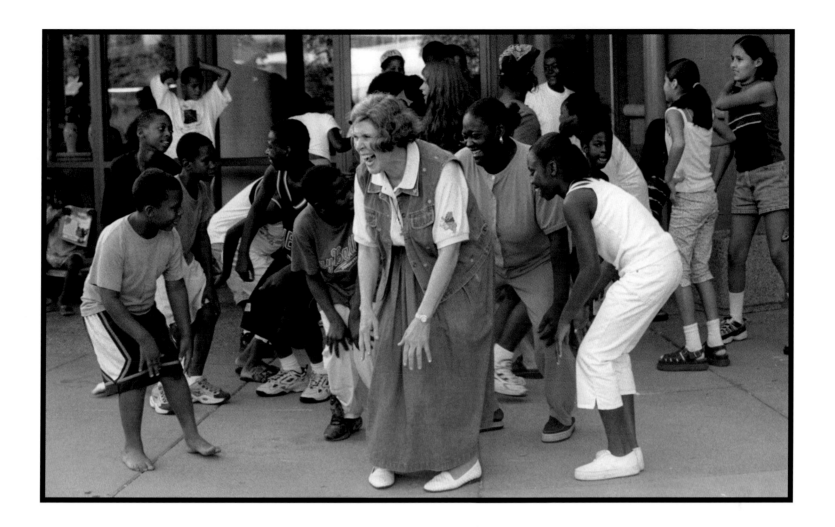

Money came, as it always has, from thousands of donors who send contributions in ones and fives, along with churches and other organizations who tithe regularly, and, of course, the big money philanthropists around town. "I call up the rich people and ask them for money," Mary Jo says matter-of-factly. "I ask for an appointment or I talk over the phone or I ask them to come to see me here." She doesn't hesitate to ask for big bucks. "I figure I'm asking them to help me do God's work," she notes. "I tell them what we're doing here, tell them that we need their help. Then it's up to them." She says her track record is pretty good. "I don't always get exactly what I ask for, but most of the time I do. People want to be generous. They see we're actually doing what we say we're doing."

The financial supporters range from the young to the recently deceased who've left money in their will. ("It's kind of weird, you don't know what to say," Mary Jo whispers. "You don't want to benefit from people dying.") Children bring their piggy-bank change at Christmas and hundreds of individuals and churches send monthly checks. "We get $5 cash in an envelope, or maybe a thousand-dollar check," Dick Copeland points out. "Some people sit down every few weeks and write a check. Others may hear Mary Jo on the radio and get inspired." The couple opens the mail over lunch in their regular booth at the Monte Carlo, a popular Minneapolis bar

"Given my druthers, I'd spend all my time with the children," says the mother of 12. She stops by the playground whenever she can and joins in songs and dances at the Thursday night gatherings.

and grill five minutes from the shelter. Mary Jo pulls a stack of the morning's mail out of her purse, along with their appetizer—an apple and orange and sliced carrots in a plastic baggie brought from home. While waiting to split the chicken noodle soup and turkey sandwich special, they sit side-by-side and tally up the checks. They spend about $360,000 a month and raise that much too, a bit less in the summer, a bit more around Christmas. Some of the regular donors are among Minnesota's wealthiest citizens and they reach even deeper, anteing up $500,000 or more when Mary Jo needs building funds.

Tom and Mari Lowe wrote their first major check to Mary Jo for Mary's Place. They liked the idea of the hotel-like apartment building and that it would have a personal touch with a variety of amenities, from a playroom for kids to microwaves and color televisions in the apartments. "It's a place for those people who fall through the cracks," Lowe says. "If you don't have a place to stay, she'll take you in."

Carrie Dahlquist is one of the thousands who've lived there over the years. A recovering alcoholic, she and her nine-year-old daughter stayed at Mary's Place while looking for work and a new beginning. "There are a lot of good women here who are trying to get their feet on the ground," she says, waving at friends as families crowd into the lobby for Mary Jo's regular Thursday night meeting. Her daughter can't wait for the spirited meeting, the hug, and the $1 bills. "Cassandra loves her," she notes. "She talks

about Mary Jo wherever we go. I'm kind of embarrassed. We're homeless and she'll open right up, ask the clerk at the store or the people behind us in line, 'Do you know Mary Jo Copeland? We live with Mary Jo Copeland!'"

Mary Jo steps into the lobby like an entertainer stepping onto the stage. Laughing, waving, she does a little curtsy and jumps into her routine. She praises the children for helping their mothers, reminds them to do their homework, brush their teeth, and "pray, pray, pray," then breaks into song. It's a little corny, but the kids love it. After acting out "the itsy, bitsy spider" and leading a few choruses of "If you're happy," Mary Jo greets the children in turn, giving them each a hug and a $2 allowance for the week. Holding them close, she asks about their day or what they want to be when they grow up. "It's important for the children, that one-on-one with Mary Jo," Carrie Dahlquist believes. "Face it, a lot of these kids don't have many nurturing people in their lives. Mary Jo is huge to them, wonderful."

A staffed childcare center, open several hours a week, allows parents at Mary's Place
the time to go to job interviews or to look for suitable housing.

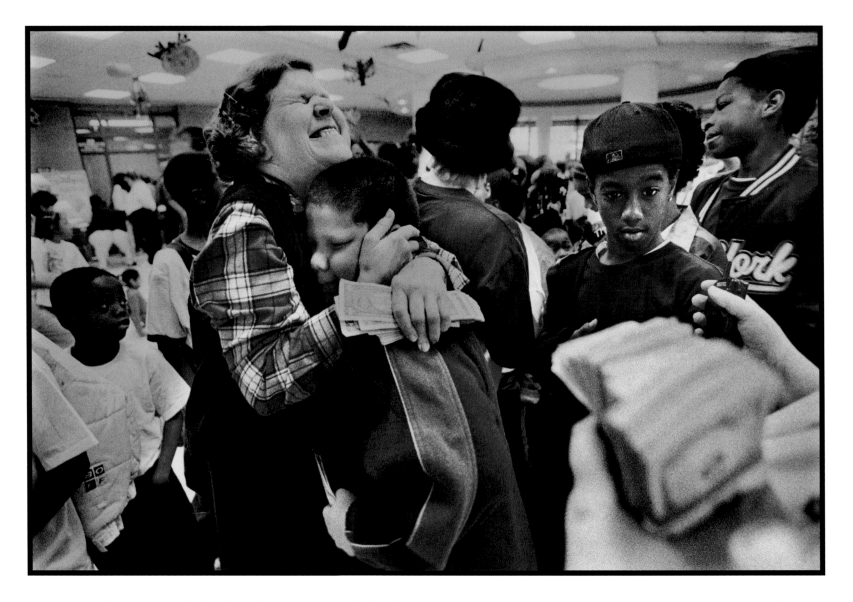

The young mother had hoped to stay at Mary's Place longer, but Mary Jo told her it was time to move on. Surprisingly, the rejection only increased Dahlquist's admiration. "She's a saint definitely. If one word had to sum it up, that would be best. When I asked her for an extension, another 30 days to stay here, she started crying because she couldn't help me. I have other options, other places I could go now, but she has so many people who have no other options. She needs the space for them. I really do understand."

Some people try to take advantage, some complain about the rules. "I've seen people try to put one over on her, but she puts her foot down. Sometimes she loses her temper. I don't blame her. There's no one else out there giving people the kind of opportunities they get here. They have to act right."

In addition to a group pep talk on Thursday nights, Mary Jo tries to have a few private words with each child. "I encourage them to decide on something positive they're going to do. Maybe they can help their teacher or be Jesus to their parents. Work hard. Pray. I want them to know that life is good."

The rules are basic and clear. Don't steal from the laundry room. Don't smoke. Don't let your kids run wild. Keep your apartment clean: wash the dishes, make the beds, put out the garbage. Volunteers inspect each apartment every day, but, as Dahlquist says, "It's nothing awful. She wants people to take care of things; that's all she asks. If people come in drunk, I'm sure she throws them out. I'd hope so. She wants to keep this a safe place. It's more a home than a shelter."

Natasha Mathews knows that for sure. She's been to the other shelters in town. "My daughter's father was battering and I had to take my four kids and leave," she recalls. "Believe me, you don't want to go to the other places–they're terrible. I appreciated it because it was a roof over my kids' heads, but it's terrible. The food they cook there, it's like b––––, excuse my French. They just throw it together. And there's rodents, mice, bugs. And they have viruses going around. You're there a week and you get it." Mary's

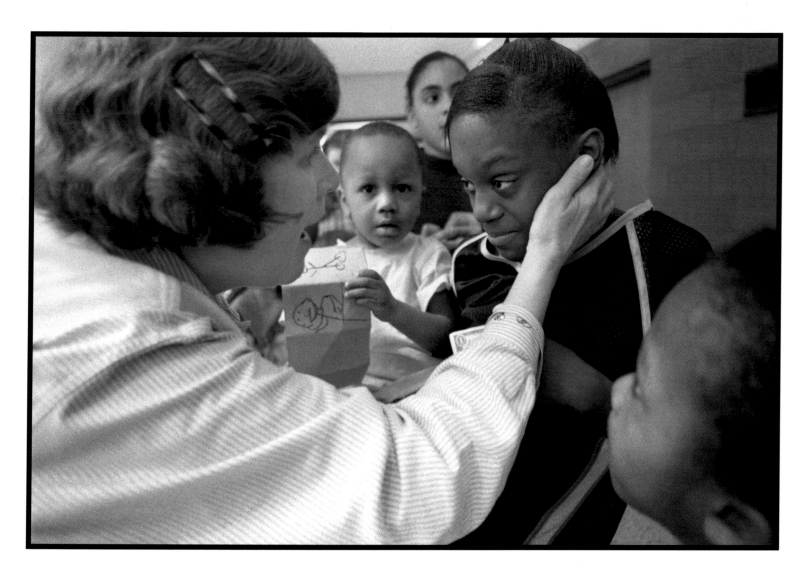

Place is like a mansion in comparison. "People walk in here and can't believe it. It's clean here. You get to cook your own food. You have your own private, clean place. You can use the phone." Plus there's help to find a better life. "The folks here taught me to use a computer, go to websites, find more opportunities," Mathews says. "They're helping me find a job. If you work with them, they'll work with you. When I leave here, Mary Jo will give me all the money I've saved. She doesn't charge you for anything; she holds the welfare money for you until you leave. It's like having money in the bank. I came in here with nothing. I came in here thinking that she only helps certain people, but that's not true. She's cool. She takes time to talk and help. It's love here. We're going to get on our feet, finally."

Over at Sharing & Caring Hands, Michelle Walker has stopped by to tell Mary Jo the great news: After several weeks at Mary's Place, she's found an affordable apartment. She and her small family will be moving on. A vibrant young mother of two, Walker was training to be a county corrections officer when she suddenly lost her home. Her landlord, eager to increase profits, converted from subsidized to market-rate rents, and she was unable to afford her apartment or find another. "Mary Jo saved us," she recalls. "She gave us a place where we could sleep in peace, safe." She also promised to pay half of Walker's security deposit when she found an apartment. "She said, 'You come up with half, I'll do half.' But I did her better! I did two-thirds, she'll do one-third." After all that help, Mary Jo now has a life-long friend. "I love her. I'll be back to volunteer. I see all the good she does."

Mary Jo hugs the family and brushes off the praise. "I try to do the right thing. I try to have a good place for these mothers and children to stay," she says, still smarting over an altercation that morning. She'd evicted a mother and her five children after the mother failed to heed warnings to supervise her children. The mother was angry, yelled at Mary Jo, said her kids would be out on the street. But Mary Jo held firm. "I don't have patience for someone who won't help herself, who won't follow the rules. I have to keep this a safe place for the other families."

Standing in line to talk with Mary Jo or commiserating over lunch in the dining room, single men sometimes mutter that she's not fair. "She favors women," Sherice Sanders, a day worker who often stops by for lunch, says. He's watched Mary Jo work over many years.

Rob Wills, Mark Copeland's friend since second grade, oversees the teen center. An Olympic-caliber athlete, Wills was paralyzed in an accident and is now in a wheelchair. "After a while, Mrs. Copeland called me and said, 'Rob, it's time to move on. God's calling you. You have to come work with these kids,'" he recalls. "How could I say no? It's been a miracle every night."

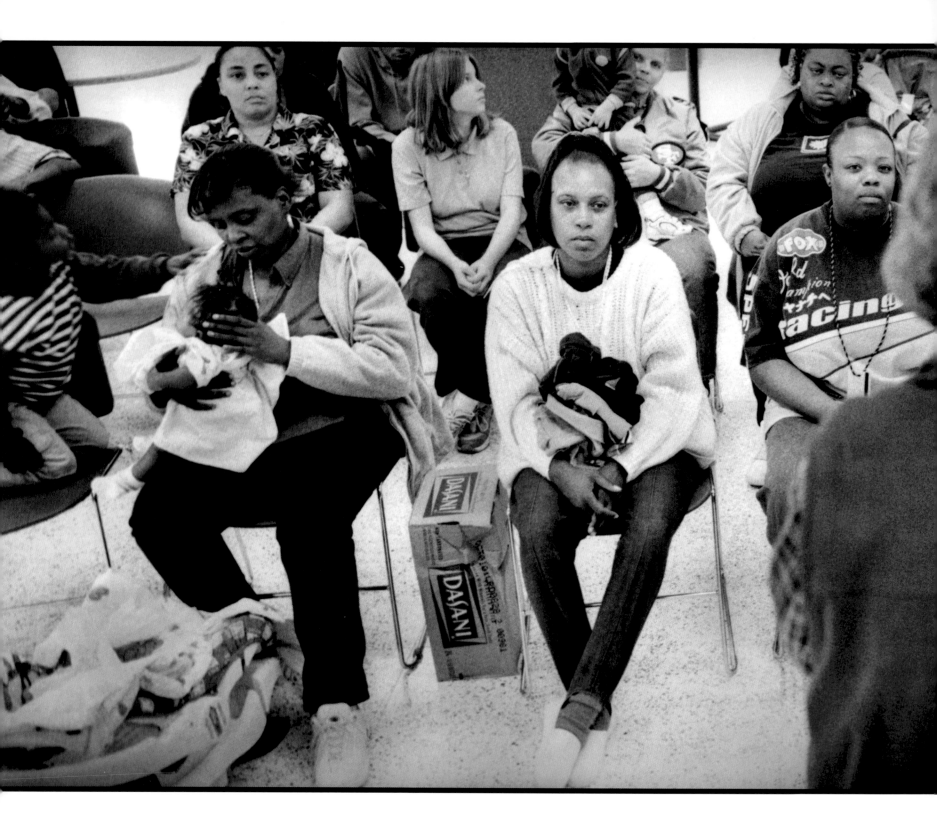

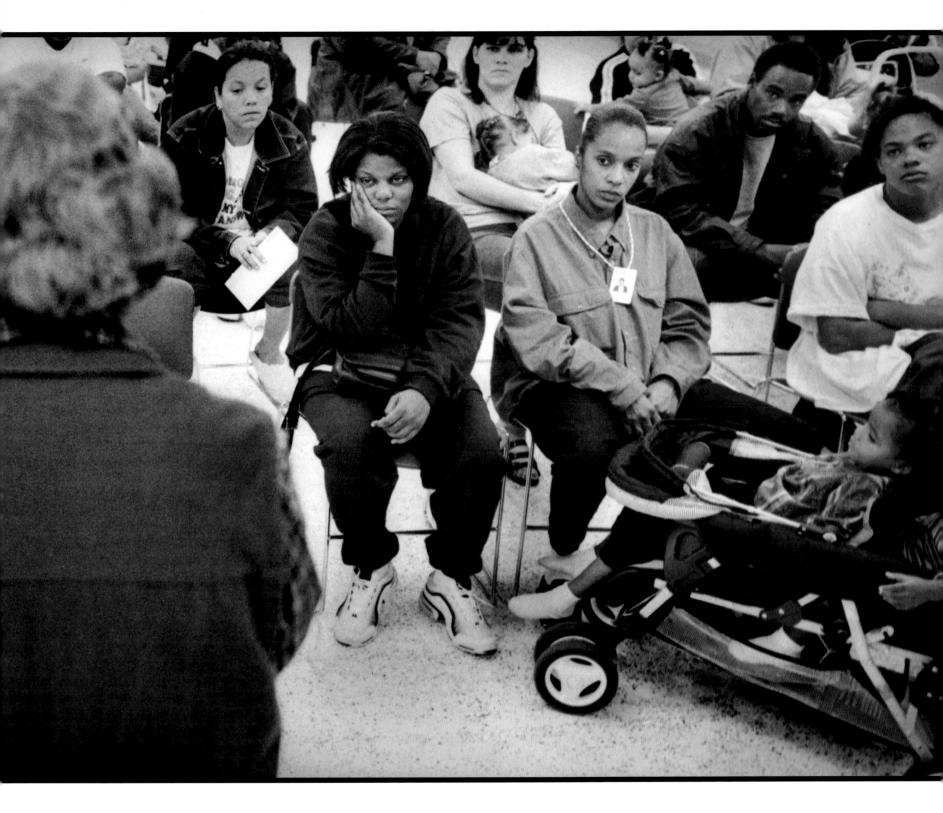

"We are called to be channels of God's peace,
instruments of His love." –Mary Jo

"You will never know what your kindness does; maybe a miracle will happen." —Mary Jo

"It's true Mary Jo does more for women and children. You get the women telling a story. Mary Jo's looking at the kids, hearing the story. She falls for it. Men don't bring the kids."

Mary Jo doesn't apologize. "I have a preference for children, that's true," she says. "And it's usually mothers who have the children. If a father comes and he's truly the one raising those children, then I help. I do what I can. But single men, most of them can be out working and they can stay in the other shelters."

She's especially touched when grandparents show up with their grandchildren. Elizabeth Fleming, 68, was struggling to care for her seven grandchildren when Mary Jo said she'd help. "I met Mary Jo in the early nineties and she's right here beside me, helping me raise these children," Fleming notes. "She took us under her wing." Mary Jo had helped Fleming for years through Sharing & Caring Hands—giving food from the food shelf, clothing from the donated bins, and money to help with rent and school supplies. When Fleming suffered a stroke in 1998, Mary Jo moved her and her charges into Mary's Place. "I figured I could keep better track of them if they were living here with us," Mary Jo says, noting that the family will live there long term, despite the usual 30- to 60-day limit on residency. "Elizabeth is a wonderful woman. I'm just trying to help."

Major donors, like Tom and Mari Lowe, say it's that kind of flexibility and hands-on effort that keeps them in Mary Jo's camp. The couple became involved in the early nineties. "We heard her on the radio asking for more toys for kids at Christmas," he recalls. "So we paid a visit to see what was going on. What impresses us is that she's working with the hard-core needy. If you give money, almost all of it is going directly to help these needy people. She sets an example for this kind of work. There's no bureaucracy. You know every nickel you give is going to a needy person who doesn't have to go from place to place, officer to officer, filling out form after form. She's a saint. It's pretty hard not to give to her."

Her best fundraising approach is simply to tell people her story and let them watch her work. "If she gets you one-on-one, it's all over," Lowe says. "But the fact is, if you go visit and see what she's doing, it's pretty hard not to help her. Everyone who goes there, ends up helping one way or another." The Lowes volunteer at Christmas and have made Sharing & Caring Hands their major

TOP: *The Mary's Place apartments include a full kitchen, a color television, and sturdy bunk beds for the children. "Some people have never lived in such a nice place," Mary Jo says. "It gives them a break, a chance to rest their souls."*
OPPOSITE: *After living in other shelters, Natasha Mathews says she especially appreciates the chance to cook dinner for her children.*

charity. But they neither have, nor want, any influence over the work. "You don't tell Mary Jo what to do," Lowe says. "She is a very strong-willed person. But she's doing wonderful things."

Since that first day, when they took a detour to meet Mary Jo, the Lowes have seen Mary Jo's work and reputation grow from the streets of Minneapolis to the boardrooms and churches, and now even to Washington, D.C., where President George Bush praises her work as an example of what the private sector can accomplish. "The work has grown phenomenally, as has the need," Tom Lowe notes. "Whatever they need, she's got it. You name it, she's doing it."

And what about all comparisons with Mother Teresa? Does the late revered nun have a clone in Minneapolis?

Archbishop Harry Flynn, who oversees the Catholic Church in Minneapolis and St. Paul, is in a position to speculate. Flynn, Mary Jo's bishop and friend, knows her well and also knew the famed Mother Teresa, having worked with her several times over 20 years. He says the two women have much in common. The archbishop met Mary Jo shortly after moving to Minnesota in 1994 when a friend took him to see her work. "I was very impressed," he recalls. "What she was accomplishing was almost miraculous. She loves the people she serves." Since then, he's seen her often, visiting the shelter "whenever they need my presence" and officiating at Mark Copeland's wedding. Flynn met Mother Teresa in 1972 and worked for her in establishing a home for her sisters in

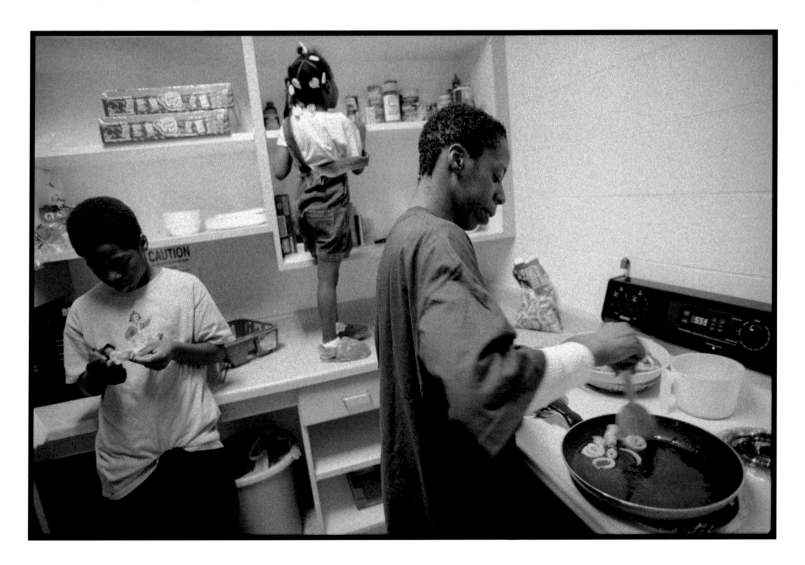

Lafayette, Louisiana where he was then bishop. He smiles as he thinks of the two women. "I see a beautiful similarity between Mary Jo and Mother Teresa. Both have a wonderful sense of humor; holy people smile easily—if one doesn't smile, there's reason to question. Both are devoted to the Eucharist—they understand what it does to us: If I really acknowledge that this is the body and blood of Jesus Christ, then I'm urged to reach out to others. Mary Jo does that beautifully, with a great deal of love, as did Mother Teresa."

The similarities continue, Flynn says. "Both loved the person first, then helped. That's how a bond is created: Mother Teresa was able to do that and so is Mary Jo. Both do impossible tasks, beyond human capacity. And, of course, Mother Teresa had a very strong will, just like Mary Jo." He remembers showing the nun a house in Lafayette, a potential home for her sisters. "It was the heart of the summer, very hot, and there were air conditioners in the windows. I thought they'd be good because the heat was so difficult to bear. But she asked if the poor had air conditioners." Flynn laughs at the memory. "So much for air conditioners!"

Mother Teresa also shared Mary Jo's contempt for bureaucracy. "She was not one for paperwork," the archbishop recalls. "When I asked her what the contract would be for her sisters to come to the Diocese of Lafayette, she said, 'No contract. Just your promise of daily mass and weekly confession.'" So, is Mary Jo Copeland another Mother Teresa? "I would say yes."

The Bland family loves living at Mary's Place. "It's a community," mother Terry Bland says. "People might never believe that a shelter, transitional housing, can actually be home, but that's what it is to me and my kids." There's little individual space with a mother and nine of her children in one apartment, but she says no one's complaining. "I like knowing my kids are safe. They can have friends over from other apartments and everyone is safe. There's no guns, no violence from the streets. It's more like what you want for your kids. Hanging out. Having fun. Just being good kids."

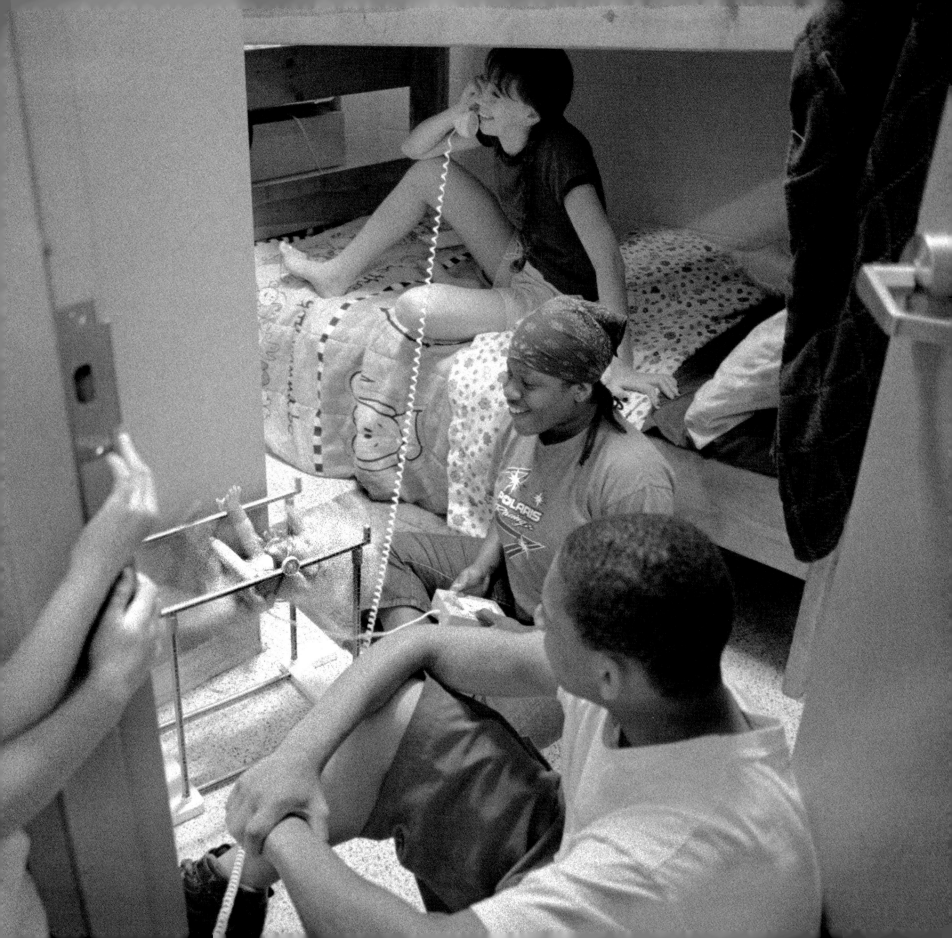

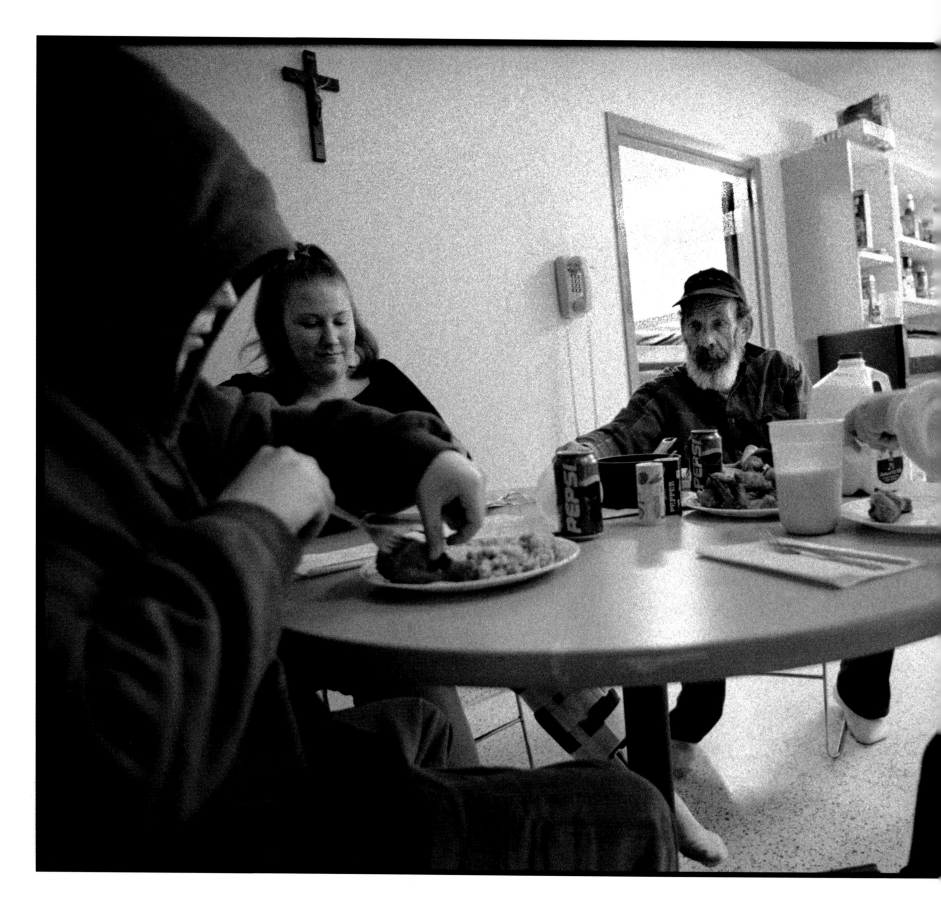

And what about all these people who call her a saint? Would the archbishop agree? He nods his head again. "Yes, I'd say Mary Jo is a saint. We don't need to be canonized to be a saint; anyone trying to do the will of God for the sake of others is a saint. I have no problem at all with people calling Mary Jo a saint." In fact, he says, popular acclamation has a long tradition: "In the early years of the church, the people would raise up a saint, not wait for the church fathers to decide."

Like Mary Jo, Flynn puts little store in labels, comparisons, or flowery adjectives. He says what's important is that people follow her example. "She might be a sign for the rest of us to reach out just a little more."

Dotty Deutsch was at her wit's end when she heard of Mary Jo. "I go out to work, but I got cut to one day a week," she says. "You can't pay rent on that, so I asked Mary Jo for a place to sleep. When we came here, I had no other options. I was at rock bottom. I wanted to keep us all together—my father, my kids. My dad can't live alone anymore and my kids need a decent home. You can't raise them right otherwise." After settling in at Mary's Place, Deutsch said she quickly felt herself grow calmer. "We can play games, eat together, be a family. I'm trying to find a better job, full-time, at least $8 an hour." Then she'll be ready to find housing and move on. "I don't want to depend on Mary Jo. I want to be responsible for myself," she says. "But I needed her help."

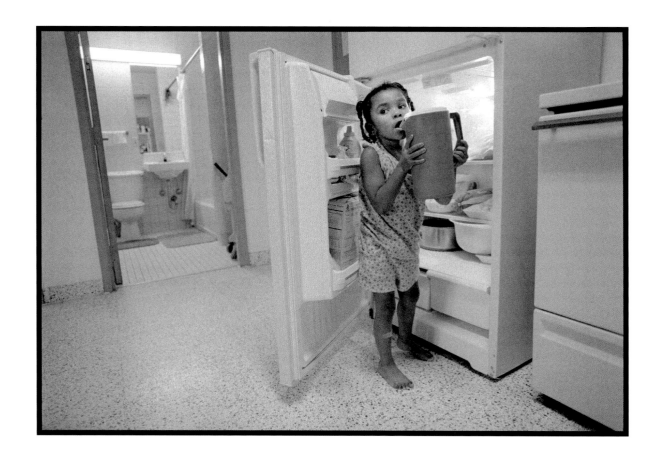

After being injured on the job, Christopher Burns was unable to find work that could pay for suitable housing and support his family. "I was very depressed to be in such a situation," he recalls. "I was raised in a nice family, and one of the values they instilled was that the mother and father should be working together in the home, providing goals for the kids and being an example. And I couldn't even pay the rent."

He stood in line to see Mary Jo and asked for help. "We prayed together and then she asked if she could put us up in a motel. Here we were in need, and she was asking me if she could help. I couldn't get over it."

After getting to know him, Mary Jo offered to pay Burns's tuition to become a medications aide; after 10 weeks he graduated and found a job. But he wasn't eager to move out of Mary's Place. "I feel so secure and safe in here. She's always stressed that this is a time to rest my soul, to rest my spirit." He attends the weekly prayer meetings that Mary Jo has for residents. "It gives me inspiration, hope," he says. "When Mary Jo first met us, she said, 'Your prayers have been answered.' And they were. Without her, my family and I would be somewhere on Skid Row."

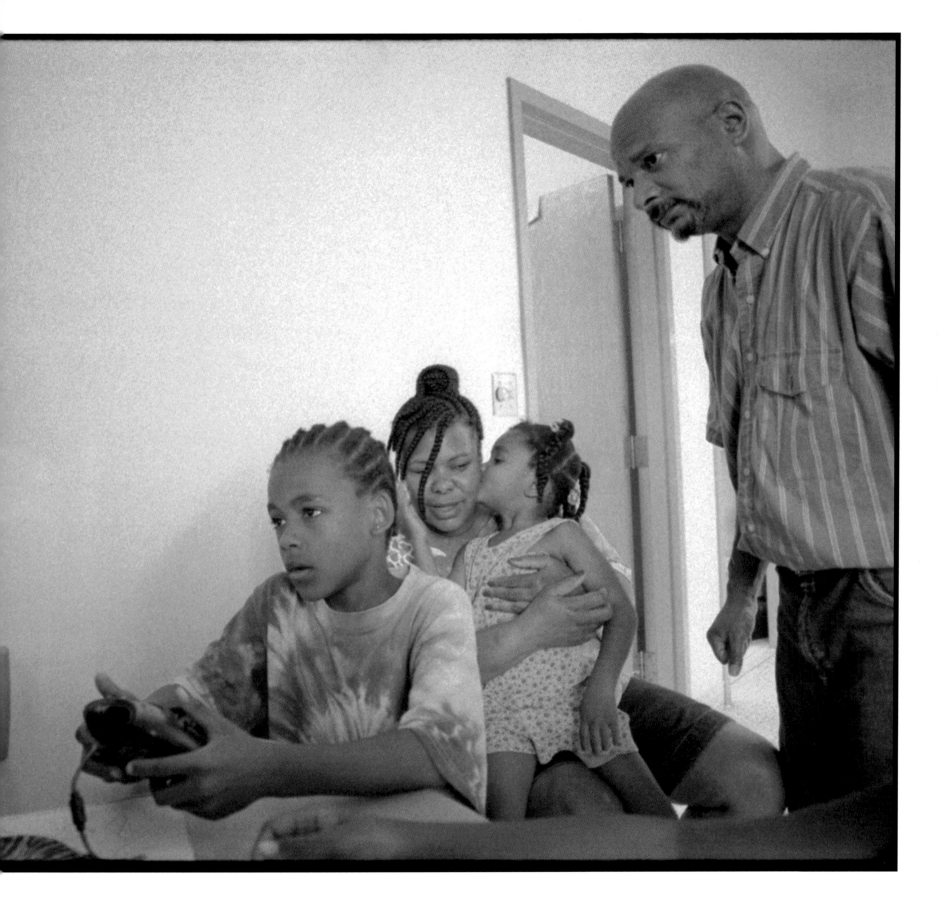

"I have 12 children altogether and nine live here with me. We have one apartment—three sets of bunk beds and a rollaway bed, and the youngest sleeps with me. We used to live in North Minneapolis but I worried all the time. I made 29 calls to 911 about the drug dealers; it was real bad there. I'd bought a house in a bad neighborhood, because that was all I could afford. Actually, I found out I couldn't afford it. I worked two jobs and was gone day and night. It wasn't good—the kids started getting away from me. I was married for 26 years, but we split five years ago and it's tough being a single mother. He's a Vietnam vet on disability, so I get some help there.

"It's safe here. There's no shootings here. And it's not just me laying down the rules; it helps that someone else is doing that too. My kids are pretty good now. I keep a pretty close rein on them. My daughters volunteer at the front desk and my 17-year-old works at Kentucky Fried Chicken. We're doing okay. My daughter got a scholarship to a nice private high school. They have more opportunities here than I could give them on my own. They use the teen center, they help out. I emphasize to them that nothing is free. I see where people get used to getting a handout, but I tell my children, 'If you're given something, you give back. Not to Mary Jo, but maybe to someone else.'"

terry bland

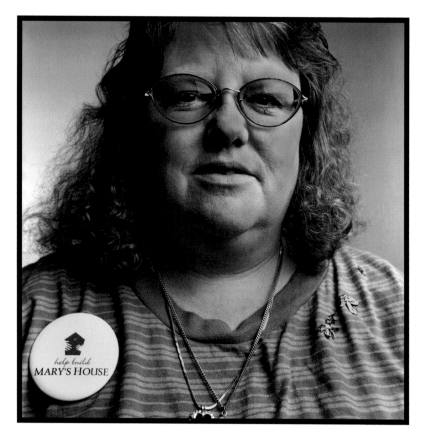

"We lived at Mary's Place for eight months last year and then got our own place. But we came back because I couldn't afford the utilities—$300-400 just for gas. The house was nice, a lower duplex, but the rent was $750 and with utilities I couldn't afford it. I never bought any groceries when we were there; I didn't have any money. I'd get groceries at Sharing & Caring Hands."

shirley johnson

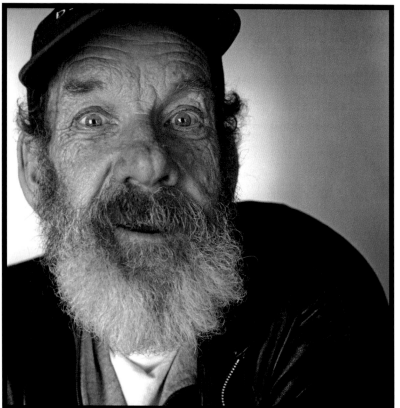

"I was married for 44 years before the good Lord took my wife. My daughter saw I wasn't eating and my mind isn't always working right. She took me in, but then we lost our place. We didn't have no other place to go. Now we're here. I watch television or sit outside. It's okay. Everything's okay."

arnold kruse

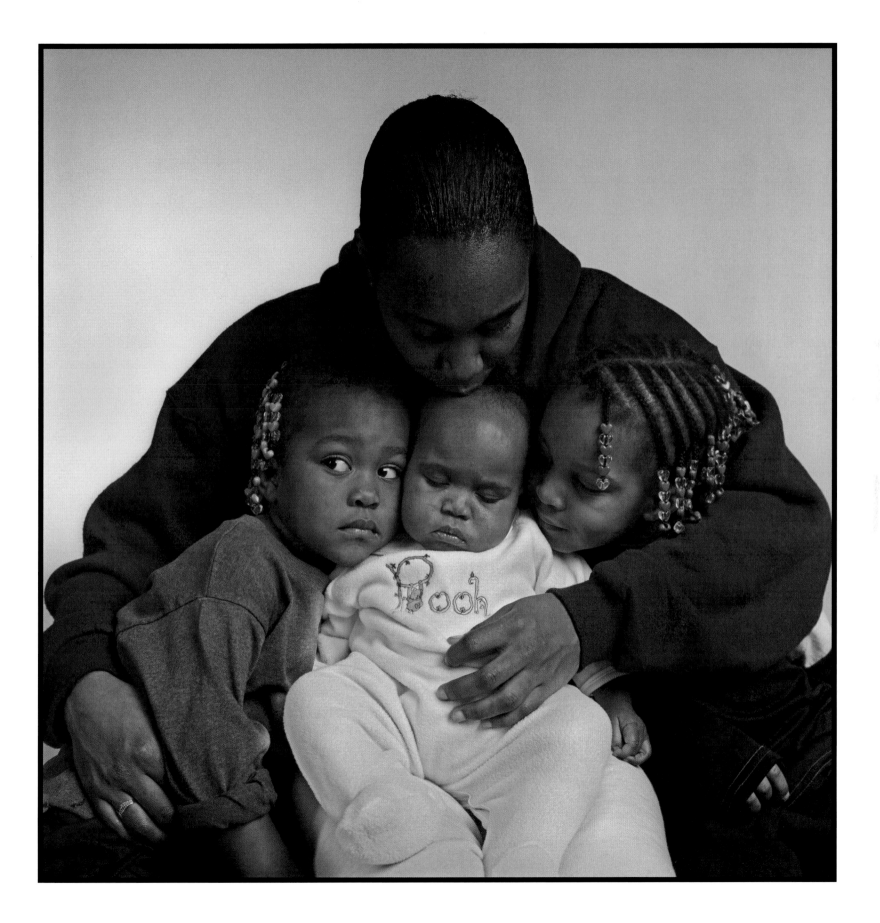

"We've lived at Mary's Place for a year and a half. I came after I was shot. I was in a four-bedroom townhouse and me and my kids were outside and I got shot, a random thing. I wasn't the target, but I lost my home; the lease wasn't renewed. I was at the end of my rope. I was very, very suicidal. I was on crutches and I hobbled up to a church. I went to ask if I'd go to hell if I killed myself.

"They brought me down to Mary Jo. She told me not to worry, no matter what, I'd have a place. It's very hard to find an apartment with four kids. My credit rating was ruined— not my fault but I'm the one out here paying. I volunteer around here seven days a week, doing what I can. Like everyone else, we're staying here free and I've been able to pay off $3,000 in bills.

"Me and Mary Jo have gotten very close. We talk all the time. I think this was meant to happen to me: I've learned so much through her. I feel I've finally found a place where I fit in. I never fit in before. I've lived a very rough life. I left home at 14, was a prostitute from 14 until about 21. I never had a place. Now my kids and I, we have a home, a safe home."

trudy mcfarland

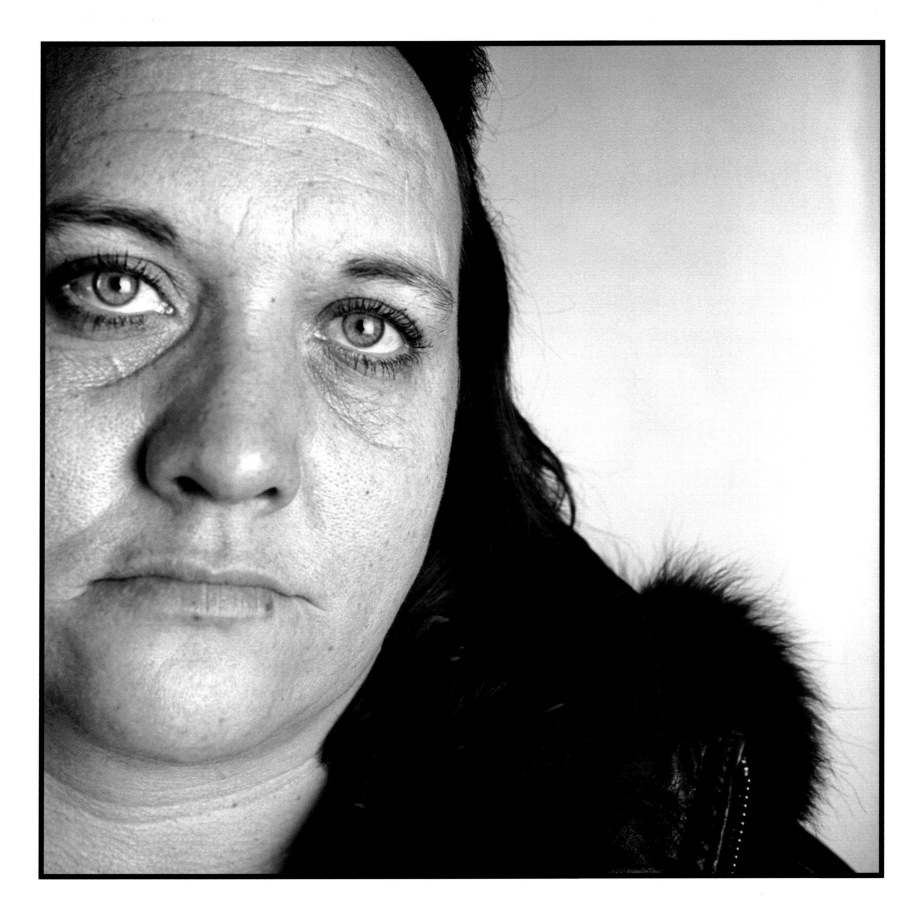

"I was always crying when we first came here, and Mary Jo would say, 'Don't cry. God brought you here for a reason.' We came in September 1999. We'd never lived out on the street, but we would have been. We were turned out of our house one day and she took us in that very day. I'd called lots of places for help. My husband had lost his job and we owed $4,000 in bills. We'd call the United Way and other places and they'd say 'We don't do that' or people would say 'Call when you're actually out on the street.' I went to the gover-

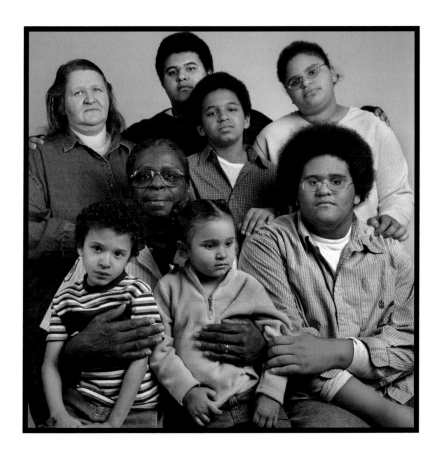

nor's office three times. Finally, the governor's office said, 'I think your best bet is to go see Mary Jo.' Our children are very protected. They'd lived in suburbs their whole life. But my kids love it here; they've learned so much from Mary Jo. When I first came, I was hateful, so much bad had happened. But Mary Jo is an inspiration, it's healing to be around her. We love her like a family member.

"I'd gone to work when the youngest was in first grade, but then we had two more babies and I couldn't work. We were doing okay; my husband David drove a Minneapolis city bus for 27 years. But he got sick and couldn't work. We got behind, further and further. Then we lost our home.

"It was traumatic for all of us. When we told the children we had to leave the house, they started crying. I never used the word 'homeless' or 'shelter.' I told them we were going to stay at a kind of religious place. And one of them said, 'Is that the lady we always see on TV?' It was scary: we thought we'd have to leave Mary's Place after a month and we didn't know where we could go. It's impossible to find housing for such a large family at a price we can afford. We talked to Mary Jo and she said, 'Don't worry about it.' She looks at each individual family and what the situation is."

pat wright

103

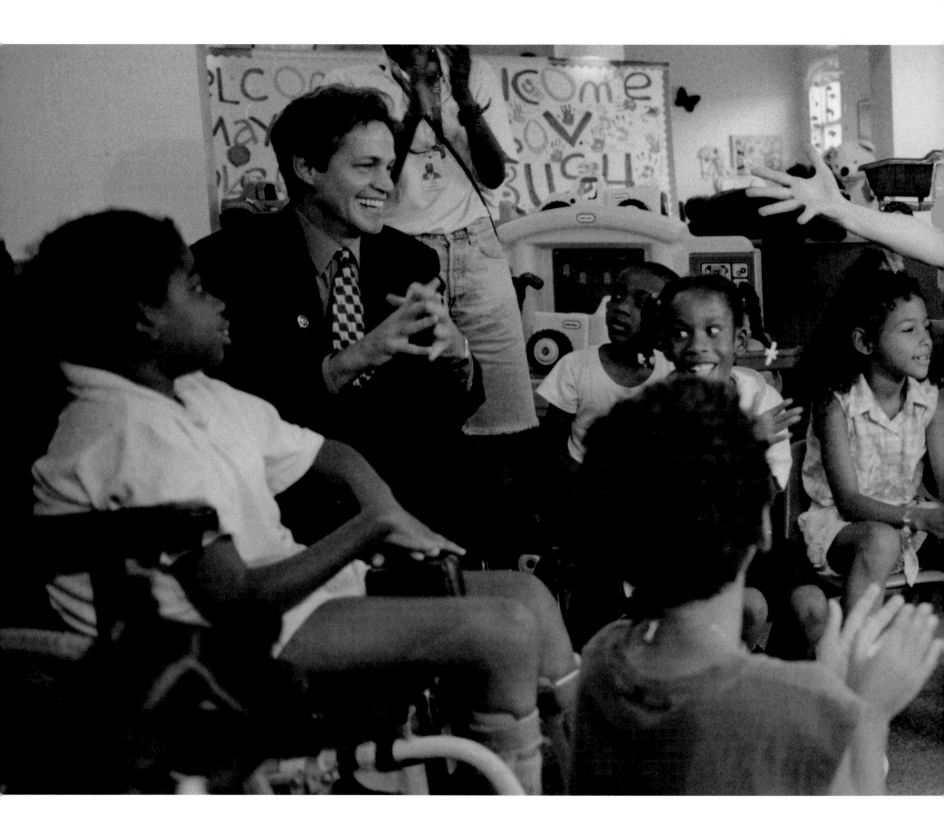

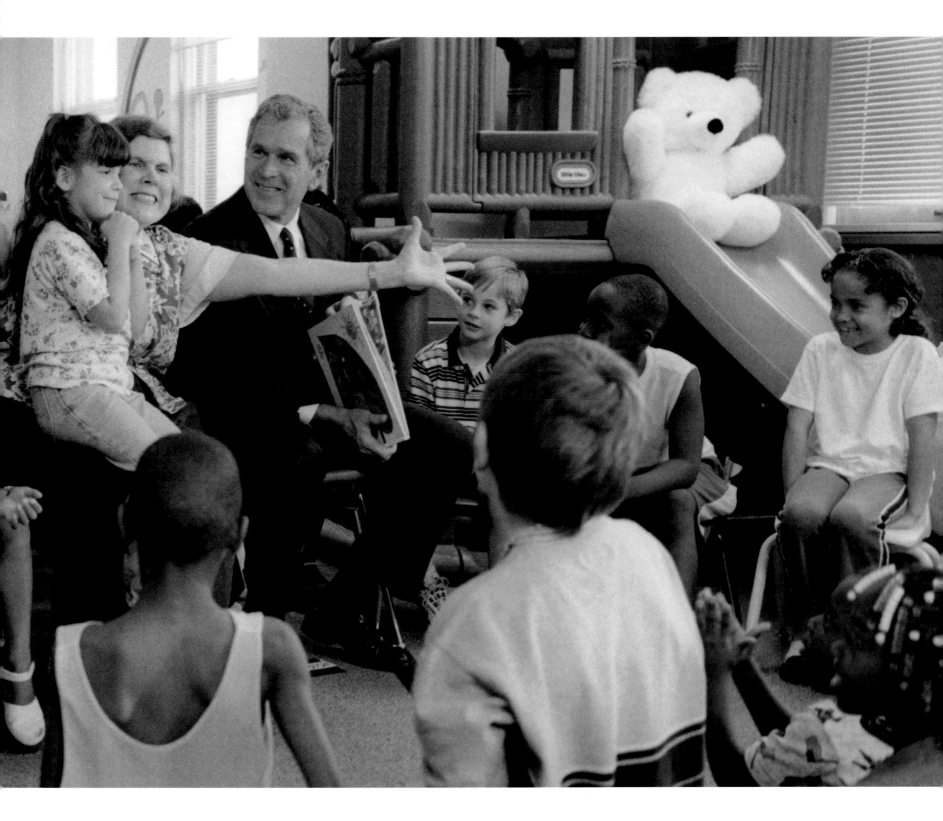

"I'm going to try to teach the world." –Mary Jo

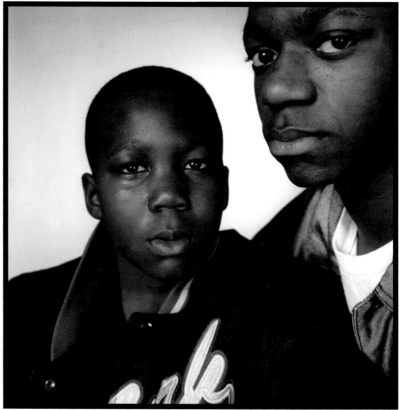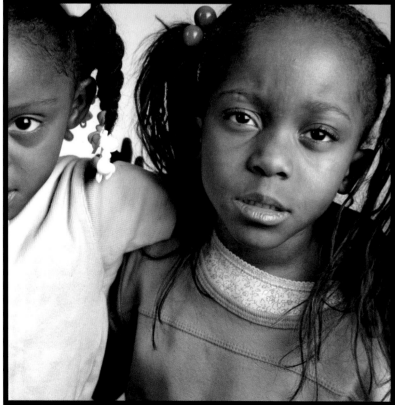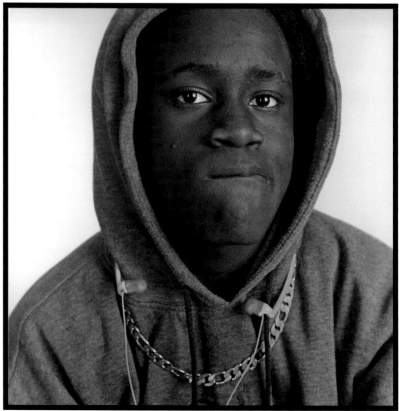

"Your smile and outstretched hand are the beginning of a miracle." –Mary Jo

The Gift of Mary Children's Home

The bright yellow building caught Gail Dorn's eye as she stood at her 28th-floor office window, watching the sunset over downtown Minneapolis. Then vice president of community relations for Target Corporation, she'd spent the day working on how the company would implement its new giving policy. From the time when it was known simply by its Dayton's department stores, through its years as the Dayton Hudson Corporation, the company had been a leader in philanthropy, spurring other Minnesota-based corporations to follow the company's lead and give five percent of their pre-tax income to charity. They'd made the state a national model for corporate giving.

Now, the newly renamed and rapidly expanding Target Corporation—Marshall Field's (including the former Dayton's stores), Mervyn's, and Target stores—was fine-tuning the company's long-time charitable giving policy. The goal: to look at all communities where the corporation has a presence and focus giving on organizations and charities that provide direct service to local people.

Minneapolis, home to Target's national headquarters, would certainly be treated generously, but specific charities that reflected its new vision were yet to be determined. Dorn looked down at that yellow building, "Sharing & Caring Hands." She'd heard of the place, the woman who washed feet, but she'd never been there. She picked up the phone and asked if she could visit.

Mary Jo remembers the call. "It was just before Christmas, 1999. A woman called and said she worked at Target and wondered if she could come to meet me. I said sure. I gave her a tour, told her about our work." A few days later Dorn called to ask if she could bring someone else by. Mary Jo doesn't remember hearing the name or the title. "But I always welcome visitors. I feel it's a way of opening their hearts to the work, to the poor."

Bob Ulrich, Target's CEO, was moved by what he saw. While she washed feet, he asked Mary Jo what Target could do to help: "What do you need?" First she asked for general funds to help at Sharing & Caring Hands, but Ulrich was interested in something more tangible. She mentioned the outstanding balance on the Mary's Place transitional apartment building. "They said, 'No problem,'" Mary Jo recalls. "They said they'd give me $1 million toward the debt." What came next was beyond anything Mary Jo could have imagined. "They asked what else I wanted to be doing. 'What dreams do you have, Mary Jo? What can we do to help?'"

Mary Jo recalls being shocked when the dining room at Sharing & Caring Hands began filling with children. "People don't realize how many children are desperate in this world. They have parents who can't care for themselves, much less a child. They are overwhelmed. They want help. We have to do something."

107

She shakes her head and grins, remembering that day. "Well, for years I've been wanting to do more for the children. I see so many children who aren't getting good care. Some mothers go over to Mary's Place and get on their feet, but so many never do. They're just too young or they're addicted or they really don't want to be mothers. A lot of them, if they could get rid of their children, they would. The children grow up without the love and care that children need, that God meant for them to have. They're never really children and they're never really part of what we think of as a family. They're just existing."

She said all of that to the Target team and then blurted out her dream. "I want to build an orphanage, a home for children who don't have a home. I want to give them a childhood: a stable place where people care about them, where they have food and a clean bed, and where they learn to pray and love God." Target signed on, pledging $1.5 million toward the building for starters. "They said they'd help me. 'We'll help you any way we can,' they said. They'd help build the building and they'd help me raise the money to pay for it along the way, the operating expenses. It was the answer to a prayer."

Her husband, Dick, and daughter Barbara flanked Mary Jo during the many hearings before suburban Eagan officials gave permission to build the children's home there.

"Jesus would never, never let a human regulation, a rule, get in the way of helping someone." —Mary Jo

rent successful and happy life. "It's true that I can't eat pasta," he jokes, noting that spaghetti was an orphanage staple that he grew to detest. "But without the structured and stable environment of the orphanage, I'd have probably been a gang leader and had a gun by age 13, knocking places over." Like many children who've spent time in orphanages, he wasn't an orphan either. His mother had died and his father couldn't manage the children and took them to the orphanage. "It was home," Hartigan recalls. "People cared about us. They helped us get the skills we needed. They helped us decide what to do after high school. They were there, almost like a family would be there. Better than most families we kids knew." He remembers when his three-year-old brother was sick and the nuns brought him to Bruce's room: "They had him sleep with me, just like you might do as the big brother in a family home."

Hartigan is confident that Mary Jo's children's home will have similar success. "Her plan is about supporting kids when no one else is around. We need a variety of options: good family homes for sure, a good foster care system, good group homes, and good orphanages so kids don't fall through the cracks." He thinks she'll have a place that others will want to replicate. "This will be an elite institution—you just walk around Mary's Place and you see that. It's the best homeless shelter and that will be replicated in the orphanage."

Another local judge, Tim McManus, a district court judge in Dakota County just south of Minneapolis and a father of five, says the children's home would give him an option he doesn't now have in family court. The social workers, the research studies, his own gut, tell him it's good to keep siblings together. "Sometimes all these kids have left is each other," McManus says. "They want to stay together, maintain a semblance of family." But, understandably, many foster families don't have room for three or four or five siblings. Maybe they can take two, but what about the others? "I agonize over these decisions," the judge says. "I'm sure many of my colleagues do too." If there were a children's home, the children could stay together. He's seen Mary Jo's work—Sharing & Caring Hands, Mary's Place. "She does good work. I look forward to seeing what she could do with the children."

Speaking to the various committees and city councils, Mary Jo spoke generally of her work and her belief in children. Dick Copeland, and their architects and attorneys, made the more specific, detailed, presentations of site plans.

Despite such credible support, criticism continued. After Albright's visit, the *Star Tribune* continued a series of blistering editorials: There's no need for an orphanage; children are better off in foster families; put the money into supporting existing families rather than creating an institution; donors beware—there aren't any children around who need a place like this. A lobbyist for a foster parent organization shouted insults on talk radio. As soon as Mary Jo announced a site, community leaders and residents began weighing in, many with an "anywhere but my backyard" perspective. Her first choice was an empty piece of land near the civic center in Brooklyn Center, a first ring suburb. Critics said the new children would overburden the school district, already struggling with a lot of poor and transient students. Mary Jo said she'd have a school onsite, a charter school that would be licensed by the State of Minnesota but would be self-contained. Some said that wouldn't be good for the kids either. Rejected, the Copelands packed up their plans and studies and looked for another site.

Over two years of looking for a town that would accept her home, Mary Jo sat through hearing after hearing—in the working class Brooklyn Center, not far from her own home; in the more affluent, more rural areas of Victoria and Chaska, a half-hour west of Minneapolis; and finally in Eagan, a middle-class enclave near Minneapolis–St. Paul International airport on the south fringe of the metro area. Sometimes studiously paying attention to the proceedings, often silently mouthing her prayers, Mary Jo stayed up far beyond her 8:15 bedtime many nights, waiting for votes, eager to provide whatever information she could. She heard one local critic say wild turkeys were more important than these children, so don't build a place that would interfere with the turkey habitat; another said (as onlookers gasped) that horses are more important, so don't interfere with the established trails. At still another hearing, an emotional protester drew tears from some of Mary Jo's supporters: "We moved here to get away from the city, to get away from black people," she said. "We don't want this here." Despite it all, Mary Jo never lost her will to forge forward. After midnight on the frigid December night when Chaska turned her down, a reporter asked Mary Jo if she was going to give up. "Never!" she said, grinning at her husband, Dick. "I'll fight for children, I'll serve the poor, as long as God wants me to do it. I'm not a quitter."

Her energy was fueled in large part by her daily work at the shelter. Every day, she'd see children she felt would thrive in a children's home. Working closely with her, Dennis Berthelsen, a county social worker who spends two days a week working with the families at Mary Jo's, says any realist knows that children are floundering. "Just today, here's an example," Berthelsen said, flipping through notes on his desk. "Young mother, 24 years old, seven kids and she's three months pregnant and they're all home-less. On her own, no work skills, no place to live, bad credit, abusive boyfriends. How can children survive, much less thrive? And the children are not to blame; they are innocent." Would these children be candidates for a children's home? "I'd hope so," he said. "Maybe the mom could get on her feet and have them back one day. Or maybe she'd leave them in better hands. It's not easy. Nothing's easy in these situations." The mother and kids had taken the Greyhound from Chicago seven months earlier and had

Mary Jo especially appreciates the steadfastness of local ministers and priests who have volunteered with her and who urge others to support her work.

been homeless ever since. "The kids are getting used to being homeless. It's normal to them," Berthelsen says, pointing out that this family is one of many, many similar examples. "The family structure is gone. Children are being left behind. We have to do something." In this case, he called child protection and conferred with Mary Jo about whether the family could stay temporarily in the community room at Mary's Place. The apartments were full, the motel that they often use for single people and small families wasn't suitable. After a few days at Mary's Place they hoped child protection workers would come up with a longer-term solution. "But we see things like that almost every day," Mary Jo says, making no effort to hide her disdain. "I try not to judge people, that's for God to do, not me. But these children are suffering. We see new problems every day and we also see the same mothers coming through again and again, each time the children a little older and probably an extra one on the way."

Mary Jo says critics of the children's home concept simply don't have the frontline experience that she has. "If anyone knows what a child needs, it's Mary Jo Copeland," she told the Eagan City Council, citing both her experience on the streets and as the mother of 12 children. She urges critics to work for what they think is best: "If people think foster homes are best, then work for

more foster homes and better foster homes. If people want to help families be stronger, help them through difficult times. I'm for anything that helps children. All I'm saying is that some children are falling through the cracks. Some children—I see them every day—will benefit from our children's home. They'll have a safe place to live, good food, people who care about them. We'll teach them to pray, to be a positive presence in the world—just like I did my own children."

Though she keeps her political positions to herself, much of Mary Jo's outspoken public support comes from Republicans. Jim Ramstad, her hometown congressman, has been an advocate since first volunteering at Sharing & Caring Hands in the early years. He's talked about her on the floor of Congress and has informally polled his colleagues to see if anyone else in the country is doing work of her magnitude. "Nobody in Washington has heard of a similar undertaking," he says. "It's really unique not to have one cent of government money." Supporters brought George W. Bush to visit Mary Jo while he was running for the Republican presidential nomination in 2000; in his acceptance speech at the GOP convention Bush touted her work as an example of how the private sector can be more effective than the government. Ramstad says he and the president are on the same page. "We need thousands of Sharing & Caring Hands to deal with poverty and homelessness in America," Ramstad says. "The solutions are beyond what we can legislate or tax for. We need a

> *"Treat people as if they were Jesus, and as Jesus would treat them. That's what we're called to do."* —Mary Jo

lot more people like Mary Jo in this country. We need a lot of this kind of hands-on compassion."

No doubt, Mary Jo is hands-on. As the children's home moves forward, she takes great joy in tweaking the architect's plans. She's glad that John Cuningham, the well-regarded local man who is guiding the project, was raised in an orphanage. "He understands what we're trying to do." The architects have been busy over the past few years, adjusting plans both to the wishes of a particular community and to the specific site. The latest plan, to be built on 37 hilly and wooded acres in a still rural-feeling section of Eagan, includes 20 homes that will look a lot like the family houses in the nearby

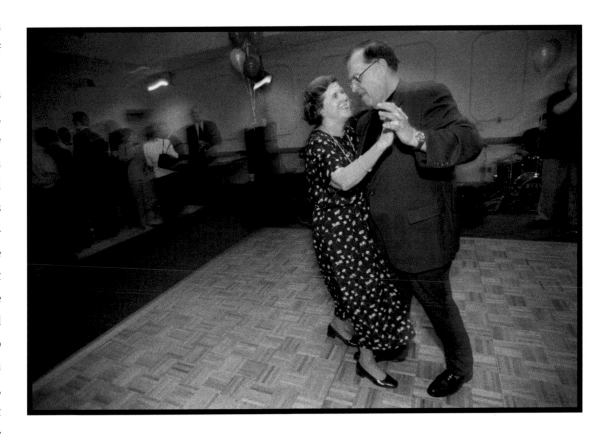

neighborhoods. Each house will be home to eight or ten children, along with specially trained house parents, married couples, and an assistant. The children will attend a private school on campus and enjoy a variety of amenities, including a community center, ball fields, and hiking trails. Mary Jo expects that some children will spend most of their growing-up years there: She plans to take children beginning at about age four and will keep them as long as they need to be there. "Some children may have other options along the way—adoption or reunion, if, for example, a parent goes through treatment and can come back and really be a parent," she says. "But for most of the children who come here, I think we'll be the best place they can be, a very good place."

Diane Perfetti-Christ has no doubt. A lifelong resident of Brooklyn Center, Diane had spoken in Mary Jo's favor at that town's hearing on the children's home. She said she would have been helped by such a home years before. "I was sleeping in abandoned cars, under picnic tables, in the park," she told city council members. "And I can't tell you how many summers I spent in the park watching Mary Jo and her children playing across the street in their yard, wondering why I didn't have a family like that. Now these children will have that kind of love, that kind of attention. They'll be happy to be in Mary Jo's children's home."

Celebrating community support for the children's home, Mary Jo spoke with long-time supporter, Congressman Jim Ramstad, and later grinned as she and Dick took a turn on the dance floor.

117

*"In the evening of our lives, we will be judged
on one thing—love, love, love."* —Mary Jo

epilogue

Almost 20 years after she began her work, Mary Jo continues at her usual vigorous pace. She's up at 3:30 to pray, then spends a 10-hour day washing feet, leading prayers, encouraging clients and volunteers, and making plans for the children's home that she hopes will open by 2006. "I'm calling up rich people and asking for money for the children's home," she says, noting that Dick and others are also contacting potential funders. She needs to raise $30 million for the building before she can be more specific about an opening date. "People should know that we've purchased the land, some money has been committed, but we need more. We need people to help. If everyone helps, we can get it built."

Now and then she wonders how to fit the fundraising into her already-packed calendar, but for the most part she's not concerned. "The money is the least of our worries," she tells people. "What's money? It's paper. It's nothing. I pray that people will support us and that God will provide. I'm sure it will happen."

She figures that the long battle to find a hometown for the children's home was worth it. "Maybe this is what God wanted of me, that I should be raising the issues, letting people know that children need help, that we're supposed to love the children," she says. "If the first town out there had accepted the children's home, people wouldn't have paid as much attention. Now people are talking about children, thinking about children. Maybe they'll even be moved to help."

Sometimes the long days cast shadows on her face. But she doesn't think of slowing down or retiring. "The need keeps growing and growing," she says. "People can't find work. They can't find housing. We keep trying to do what we can to help." She hopes that the Catholic nuns who came from Nigeria to work with her (and are housed in an old convent several blocks away) will one day take over her work. But that won't be until she dies. "This is my life. This is what God intended for me. I know that for sure," she says. "I have been blessed."

OPPOSITE: *Mary Jo is thrilled to have her husband working beside her. "People ask me what it's like to live with a saint," Dick jokes. "Oh, the stories I could tell!"*

A Lasting inspiration

Margaret Nelson, friend and reporter, had been telling me for years about Mary Jo and her steadfast work for the poor. Then the phone rang. I got goose bumps. *People* magazine assigned me to her story. Finally. I was going to meet her! By the end of those first few days spent photographing her at work, I fell in love with Mary Jo. Years (and hundreds of rolls of film) later, I continue to be inspired by her generosity, vision, and commitment.

She's amazing! Not only is she always thinking of others, she does so with a wink, a smile, a dance, and a prayer. Exhausted from trying to keep up with her, I still felt fueled by her electricity—Mary Jo's being. If there was ever an example of how much of a difference one person can make in this world, this woman showed it to me. Through altruistic optimism, hard work, and prayer, it is possible to make your dreams come true—which in her case is a life devoted to saving body and soul.

When people criticize Mary Jo for whatever reason, I always want to ask what they have done lately to help address the suffering that she helps alleviate every day. Some don't like her faith-based work or her "unorthodox methods," such as making decisions as she thinks best rather than what the "rule book" will allow her to do. On the other hand, some whom she serves every day don't like that she favors women and children, or that she seems to like some people more than others. She is human. She is doing the best that she can. It's a miracle really.

Photography is my passion and my path. It is the way I learn and grow. The people I met at Mary Jo's shelter have touched my heart. Mary Jo and her example of how to help others are clearly worthy of examination. By sharing my small part of her story, I hope she will inspire others to emulate her by giving away shoes from the trunk of a car, by volunteering at a homeless shelter, or simply by mentoring and sharing love with the children of the world. Each person has a chance to leave the world a better place for their being a part of it. Mary Jo has helped me believe.

keri pickett

acknowledgments

From the time we began wanting to tell this story, many, many people have contributed their encouragement and counsel, their friendship and support. We are grateful to you all. In particular, and at the top of our list, we thank Mary Jo Copeland for opening her life and work to us, and for living in a way that calls all of us to consider carefully how we use our own time and talents. Thanks, too, to Dick Copeland for the special role he plays, and to the hundreds of people we have had the privilege to know at Sharing & Caring Hands—current and former clients, volunteers, staff, donors, and supporters of all kinds. We, and this book, are richer for your having shared your stories, for your grace and openness.

We are also deeply grateful to those who helped bring this book to publication: to Laura Barker and WaterBrook Press/Shaw Books for sharing our vision; to Gary Chassman of Verve Editions for his belief in this project, and for his unstinting efforts on our behalf; and to Target, particularly Gail Dorn, Bob Ulrich, and Laysha Ward, for enthusiastic encouragement and the Foundation's generous financial support. We also thank Stacey Hood and Pam Arnold for their creative design work.

Personally, I, Margaret, thank all who have been lights in my life, especially during these recent years. Special thanks to: Cindy Dampier, Giovanna Breu, Leisa Marthaler and my dynamic colleagues at *People* for fabulous opportunities, friendship, and support over the years; to my generous writing friends—Elizabeth Austin, Ann Bauer, Joel Hoekstra, Dale Korogi, Kit Naylor, Susan Perry, Cheryl Reed, Martha Roth, and Jane Trenka—for thoughtful comments, graciously bestowed, and for sharing this creative life with me; to Stan Brinkhaus for his love, kindness, and good humor; and to my daughters, Elissa Nelson, who was an early and thoughtful reader, and Emily Nelson, who spent a summer volunteering at Mary Jo's childcare center and shared her experiences with me. Of course, I am particularly grateful to Keri Pickett, my collaborator on this and many other projects, for sharing her talent, vitality and spirit with me over many years of friendship and work.

I, Keri, personally feel grateful for the love and support of my extended family: B.J. and John French, Al Mahling, sis Kim Mahling Clark, Uncle Roy Blakey (my fabulous studio partner), Michal Daniel (the love of my life and a great photographer), and my many wonderful friends and colleagues. I want to thank all the photo editors at *People* and *Time* who enrich my life with assignments to tell stories through pictures. Photography is my passion and the Minnesota Center for Photography played a vital role in support of this project. Thanks also to George Byron Griffiths for his friendship, assistance, and darkroom expertise, and to Keegan Xavi, Kristin Shue, Kristina Kienholz, Miranda Brandon, Nicole Kendricks, and Ann Silver, who lightened my load—both literally and figuratively—during this time. My favorite word editor, Mom, (B.J.), patiently continues to help me understand the English language. Marc Maxim helps me understand the Quark language. Working with Margaret Nelson is so enriching because she is truly interested in people and her heart is made of gold. She is a role model for me for putting your beliefs into action. She, like Mary Jo, sees a need, not a problem, and through steadfast, genuine interest and support, she gives and gives.

Finally, thanks to you, our readers: We hope this book inspires you to live with renewed generosity and love.

margaret nelson keri pickett

"Yesterday's over. We don't own tomorrow. Today is all we have." —Mary Jo

author Biographies

MARGARET NELSON has worked as a journalist since the age of 15, beginning in high school as local correspondent from her hometown to the nearby daily newspaper. A graduate of Northwestern University's Medill School of Journalism, she's since written and reported on a wide variety of subjects for many national and international publications, including *People, Newsweek, USA Today,* and the *Los Angeles Times Syndicate.* She has received numerous reporting and writing honors over the years and several of the stories she has covered have inspired books or movies.

Based in Minneapolis, Minnesota, Margaret is active in the writing community and in activities connected to her church, arts, and social justice interests. She was a founding editor of *Basilica*, the award-winning quarterly magazine of the Basilica of Saint Mary, speaks regularly to college journalism classes, and mentors young reporters. While working on a project for World AIDS Day in 1997, she met a mother and two children who later became her godchildren. They have given her a close-up perspective on the impact of poverty and illness that has influenced this book and her life.

The mother of two grown daughters, Margaret is now working on her second book.

KERI PICKETT has been a professional photographer for more than 20 years. Her journalistic work focuses primarily on human interest feature stories and environmental portraits that capture the essence of her subjects. Her clients cover the spectrum of magazines from *People, Time* and *Life,* to *Geo, Parenting,* and *Christianity Today.* Her personal photography projects have earned fellowships and grants from the National Endowment for the Arts and numerous Minnesota-based charitable foundations, including Bush, McKnight, Jerome, and Target. Photos from her book on her grandparents' love story, *Love in the 90s,* (Warner Books, 1995) have been exhibited and published throughout the world.

In her long-term personal projects, such as the Mary Jo Copeland story, Keri attempts to portray human struggles and aspirations in ways that help people understand each other, overcome their fears, and reach out to one another. A cancer survivor, Keri has focused her camera on, among other subjects: children coping with life-threatening illness, Native American spiritualism, Tibetans' resettlement in America, as well as on her family. Based in Minneapolis, she travels the globe—always working on her next photography project about a personal yet universal aspect of our life and times.

Please contact the authors at savingbodyandsoul.com.
We'd love to hear of the people who inspire you.

For further information about Mary Jo Copeland's work or to make a donation,
contact Sharing & Caring Hands at 525 North 7th Street, Minneapolis, MN 55404 or phone 612/338-4640.

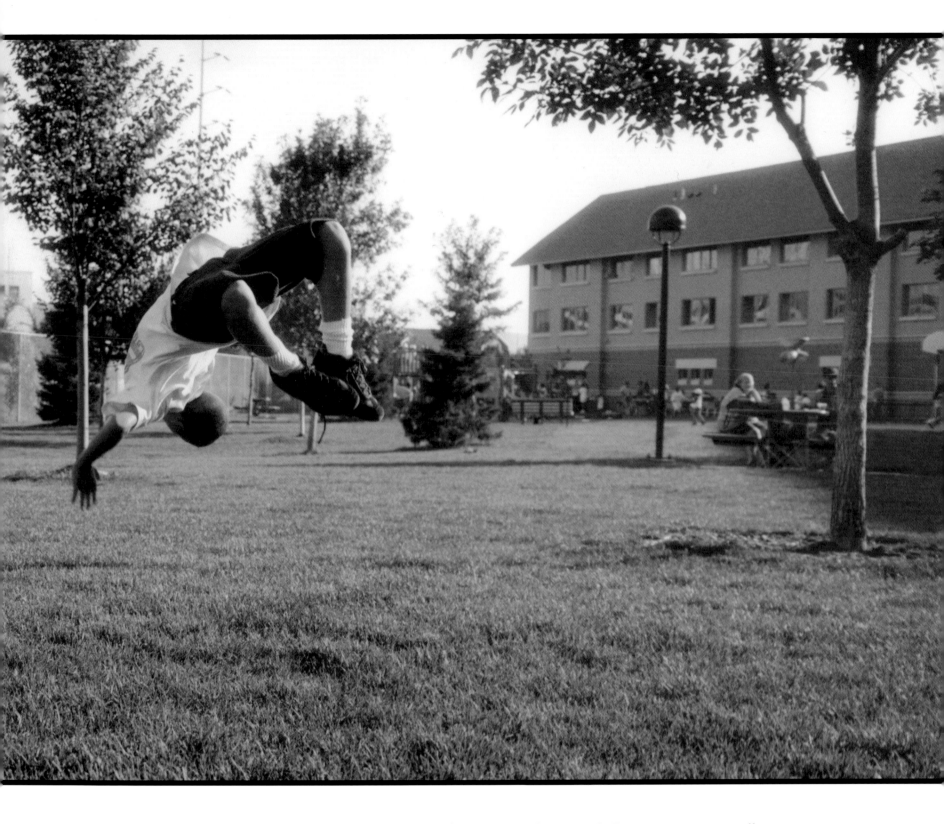

"Today is the first day of the rest of your life. Live. Serve." —Mary Jo

A SHAW BOOK

PUBLISHED BY WATERBROOK PRESS
2375 Telstar Drive, Suite 160, Colorado Springs, Colorado 80920

SHAW BOOKS and its aspen leaf logo are trademarks of
WaterBrook Press, a division of Random House, Inc.

Library of Congress Cataloging-in-Publication Data
Pickett, Keri. Saving Body & Soul: The Mission of Mary Jo Copeland /photographs by Keri Pickett;
essays & interviews by Margaret Nelson.
p. cm.

ISBN 0-87788-194-4
1. Copeland, Mary Jo. 2. Women social workers--United States--Biography.
3. Women social reformers--United States--Biography.
I. Title: Saving Body & Soul. II. Nelson, Margaret, 1947- III. Title.
HV40.32.C66P53 2004
361.3'092--dc22 2004041707

Printed Through Palace Press International

2004

10 9 8 7 6 5 4 3 2

Developed and Produced by

VERVE
EDITIONS

Burlington, Vermont
www.verveeditions.com

Book Design by Stacey Hood, www.bigeyedea.com